Santiago Canyon College

Color Management in Digital Photography

Brad Hinkel

Color Management in Digital Photography

Ten Easy Steps to True Colors in Photoshop

Brad Hinkel, bradhinkel@msn.com

Editor: Jimi DeRouen
Copyeditor: Deborah Cooper
Layout and Type: Josef Hegele
Cover Design: Helmut Kraus, www.exclam.de
Cover Photo: Brad Hinkel
Printer: Friesens Corporation, Altona, Canada
Printed in Canada

ISBN 10 1-933952-02-4
ISBN 13 978-1-933952-02-6

1st Edition
© 2007 by Rocky Nook Inc.
26 West Mission Street Ste 3
Santa Barbara, CA 93101-2432

www.rockynook.com

Library of Congress catalog application submitted

Distributed by O'Reilly Media
1005 Gravenstein Highway North
Sebastapool, CA 95472-2811

Preface

Digital imaging technology seems to be changing everything about photography these days including cameras, printers, photographic styles, editing techniques, and so on. Yet, most digital photographers seem to want to remain photographers. This means that they mostly want to go out into the world, capture wonderful images and get these images out of their cameras and onto beautiful prints. The process is a fairly basic one, yet technology has made it quite a challenge for most digital photographers.

My goal is to simplify the language of digital photography and make it accessible to those who just want to make photographs. Color management is one of those essential stumbling blocks in digital technology. The vast majority of digital photographers really wish they didn't have to care about color management, yet the basic process of moving images from capture to print becomes impractical without it. I want to simplify the language of color management.

This book is based on classes and workshops I have given to hundreds of students of digital photography at the Rocky Mountain School of Photography and the Photographic Center Northwest. My process for color management is intended to provide enough information to create a simple and effective system that allows you to get on with photography. For the vast majority of my students, the steps I cover in this book are sufficient for their entire photographic workflow, although a few students have gone onto more advanced techniques for color management. Don't let the fact that I focus on simpler techniques lead you to think that my workflow is not effective. Simpler is usually better if it works. So start working through the ten steps and get your color right.

Acknowledgements

My first thanks go to Uwe Steinmueller from Digital Outback Photo for helping me publish this book. In particular, I need to thank him for his patience after I worked through 75% of the book and then decided that I needed to start over again.

I especially need to thank those who gave me the opportunity to start teaching photography. Neil and Jeanne Chaput de Saintonge who hired me straight out of the RMSP summer intensive to start teaching their first digital photography courses, mostly due to Neil's instincts more than my personal portfolio. I'd like to thank Tim Cooper & Jim Hanson with whom I taught so many workshops and from whom I learned more about photography and how to enjoy it. I'm grateful to Jennifer Schramm and Claire Garoutte who hired me at PCNW when the digital lab consisted of two computers in the back of a classroom.

I need to thank my wife, Sangita for putting up with the amount of time spent on just completing the last details. And my aunt Jeannine who worked so intensely on wordsmithing my original text to make it simpler.

Finally, I need to acknowledge Raja and Pablo for their late-night support during this project. And Mira Nisa and Anjali for teaching me some perspective on what is really important.

Thanks to all – Brad Hinkel, March 2006 www.bradhinkel.com

Contents

Introduction

Most digital photographers start with one seemingly simple goal: to match their prints to their monitor images. This may seem like a reasonable goal, but a host of technological issues conspire to make prints and monitor images appear anything but the same. I imagine that you can create great images on your computer screen, but the printed results often look far less beautiful.

The fundamental goal of this book is to help you setup your monitor and printer so these images match.

There are three major tasks required to achieve this goal:

1) Configure your software for color management.
2) Setup your monitor to display images accurately.
3) Setup your printer to print images accurately.

Each of the tasks listed above is essential to achieving good color in your prints. Through various steps in this book, we will ensure that all three are working properly.

Once they are, you will be able to maintain a consistent relationship between your monitor and printer, making it feasible to proof and edit images on your monitor and know that the prints will match.

It is essential that I point out that monitors and prints can never truly match. These are very different devices for rendering color. Monitors are brighter and display greater contrast than images on paper, and they are particularly good at rendering shades of red, green and blue. It is important to remember that the image on the monitor is merely a proof of the final print. Most color management experts will go to some length to make sure their clients don't expect their prints to exactly match their monitor. However, when using a good color management system, your monitor should provide an accurate proof of the final print. After gaining some experience working with your system, you should be able to know what your prints will look like by proofing the image on your monitor.

My main strategy to reach this goal is through a color management workflow consisting of ten steps. These steps are outlined in the next section, "Ten Steps to Color Management." Most of this book involves working through these steps. In many of these steps, you will choose between a few options; some easy to implement, some to produce better results. I recommend trying the easy options first. They often work well enough and are usually a much better place to start.

A couple of minor caveats –

This book does not attempt to cover all the details of color management. In fact, I admit there are a few places where I oversimplify and leave out some details of color management (easily noticed by any color management professional who reads this book). My goal is to strike a good balance between explaining enough detail to easily set up your digital darkroom and eliminating some unnecessary details that could make it more difficult.

Additionally, this book does not cover all the elements of color management. In particular, I don't cover how to calibrate scanners or digital cameras. For most users setting up a digital darkroom, there is no need to worry about scanner or camera calibrations. A majority of photographers never bother to resolve these two elements of the digital darkroom. I will provide more detail on profiling scanners and cameras on the website (www.easycolormanagement.com) in the future.

You will probably end up spending some money after reading this book: maybe $100, maybe $1000. I wish I could give advice to those setting up a new digital darkroom before they spend any money, but people usually take my classes or read my book after buying everything they think they need (or have been told they need). So, stop, put your money back in your pocket, and read the book first. Hopefully, you can get your darkroom up and running with a minimum of new expense.

Finally, I make some specific recommendations on equipment, software, and printer supplies. I make these suggestions because I am confi-

dent they will work for you, but I don't claim to offer a complete list. For example, I recommend some printers I have successfully used, but I know other good printers are currently available which I have not personally used.

Following are a few notes on the format of this book to keep in mind while reading.

Hopefully, I've left out just the right amount of extraneous detail on computer technology and color so that you can easily read this book in a couple hours. Even so, I've added some visual aids throughout to identify key points and extra details.

Key points are printed in bold inside a separate box.

Web links are identified by a grey typeface and refer to the companion website for this book at www.easycolormanagement.com or they give the URLs for Internet pages with additional relevant information.

Finally, this book is based on performing ten essential steps for color management. Each step has an associated number that refers to the list in the next section, "Ten Steps for Color Management". Steps 7 – 10 are for advanced printing and may be ignored if you are satisfied with simpler printing.

I also include an appendix of some specific recipes for color management. The set of recipes includes my recommendations for setting up several different types of color-managed digital darkrooms – from a simple (and inexpensive) but effective setup to a comprehensive, professional setup. Each of these digital darkroom configurations works well and can be used as guidelines to create your own digital darkroom.

Again, this book is not designed to be a comprehensive treatise on color management, but rather an introduction. At the end of the book, I include some notes about further considerations and resources on color management.

Thanks for purchasing this book. Hopefully these primal steps through color management will prove fairly painless – and even fun!

Ten Steps for Color Management

Here is my ten-step program for setting up your color management system. I like teaching color management through these steps, since most of the concepts are taught alongside specific tasks. If you perform each of these tasks, you should have a color management system that functions well.

Each step has its own chapter in the book, so you should easily follow the required steps (and the concepts that I put in alongside each step) as you proceed through the book.

1 Choose a Color Space

Colors in the computer are not simply defined by values of RGB (Red, Green and Blue). A color space is required to define the specific colors represented by a set of RGB values. Most users choose either sRGB (easier) or Adobe RGB (harder) for their color space.

2 Get a Good Monitor

Your monitor is the essential tool to "see" the image that is stored inside your computer. A poor quality monitor merely displays poor quality images. A good monitor does not have to be an expensive option, since there are a number of good monitors available for around $200. For starters, I recommend that you stick with your current monitor, and I will provide some options for testing your system.

3 Create a Good Work Environment

The most commonly skipped step in setting up a digital darkroom is one of the easiest: create a good work environment for evaluating and editing color. You need to configure your computer desktop to be as gray as possible. Remove distracting colors from your environment and get a good light for evaluating prints.

4 Calibrate and Profile Your Monitor

Even the best monitor still needs to be configured properly to produce the best possible colors. Calibration involves setting up your monitor to properly display colors. Profiling measures and corrects the specific color errors for your individual monitor. A well-calibrated and profiled monitor produces a very good display of the images from your computer.

5 Get a Good Printer

Your printer is the tool you use to create your final printed product (unless you are only making images for the Web). Most modern desktop printers produce excellent results, and online printing services are available to create high quality prints. I recommend that you start with your existing printer or an inexpensive desktop printer for your digital darkroom. There are many excellent professional printer choices you can eventually consider after you have gained some experience with digital fine prints.

6 Create Basic Prints

– Have the Printer Driver Manage Color

The basic printing option is to print using the easy, built-in options in the printer driver software that came with your printer. Online printing services are also very simple to use. These basic printing options are limited in terms of the papers that you might use for printing, but are a very good place to start and suffice for the majority of photographers.

7 Test Your Color Management System

After you have all the basic steps completed, test out the various elements - software, monitor, and printer, using a set of standard test images.

8 Create Advanced Prints

– Manage Color using Printer Profiles

The limitations of basic printing can be overcome if you manage the color of your images yourself by printing with printer profiles. Primarily, you can improve how precisely the image on your monitor and the printed image match, and you can usually access the full range of colors available to your printer.

9 Obtain Profiles

In order to print with profiles you need to obtain profiles that are specific to your printer and the paper type on which you want to print. Profiles made by professionals can be downloaded over the Internet,,or you can make them yourself.

10 Adjusting Colors for Advanced Printing

If you want to go through the additional steps for printing with profiles, I suggest you also carefully adjust your colors for the best possible print.

These are the basic ten steps for color management.

What is Color Management?

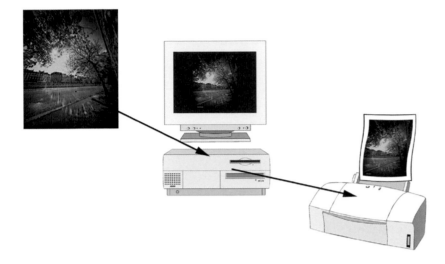

I think of color management as one great solution to the gap between computer science and engineering.

In computer science, data is absolute. Actual errors in computing numbers in a computer are so rare as to be insignificant. Computers don't make mistakes; they do exactly as they're told, even if that implies running code that will crash the system. For color management this means the color value for any particular pixel is precisely known. The value of R140 G12 B12 is a well-defined, specific shade of red to the software in your computer. (To be precise, the specific values of R, G, and B need to be defined within a particular color space in order to define a specific color – more on color spaces in Step 1.)

But in engineering, nothing is absolute. One of the major elements of engineering is understanding the errors in real world calculations and accommodating for them. Computer monitors and printers are real world devices. If your monitor projects the value for a particular shade of red onto its phosphors, it is very unlikely the monitor will actually display that specific shade of red. It will probably display something that looks fairly red, but not the exact intended shade. Color management allows us to measure the errors of real world devices (like monitors and printers) and correct for them.

The first key to understanding color management is to realize that your digital darkroom actually contains three different versions of your image – the virtual image inside the computer, the image on the monitor, and the image printed out by your printer.

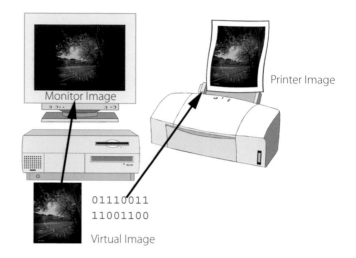

The virtual image is what the computer (or Photoshop) thinks your image is. This is the exact digital image, and for color management, we will assume this is the most precise version of your image. The monitor and printed images are not precise. They are corrupted by the inexact nature of your monitor and printer.

▸ Your digital darkroom contains three different images – the virtual image inside your computer, the monitor image, and the printed image. The goal of color management is to make both the monitor image and the printed image appear the same as the virtual image.

Let's take a closer look at the monitor image. The monitor image is an attempt by your computer and monitor to display the virtual image onto the monitor, but it fails to do so exactly. For example, assume that the virtual image contains this specific shade of red – R140 G12 B12 in the sRGB color space (I'll refer to this as "Red#87" from now on for simplicity). The computer knows the exact value of Red#87, and it will always be this exact value as long as it is contained within your computer. But the monitor fails to display Red#87 exactly. Let's say the monitor displays Red#87 +3 points too blue – so you won't see the exact same shade of red on your monitor. In fact, most people at this point think the red inside their virtual image has a little too much blue it in and try to correct out this blue, thus changing the Red#87 to something else entirely. But what if we can correct the value of Red#87 *before* we send it to the monitor? Knowing that Red#87 is displayed as three points too blue, the computer can merely take out three points of blue from the Red#87 before sending it to the monitor, which then adds back in three points of blue, and voilà, the monitor displays Red#87.

In fact, this is what the color management engine does: recognizing the error for a specific color on a particular device, it can correct for that error inside the computer before sending the color onto that device.

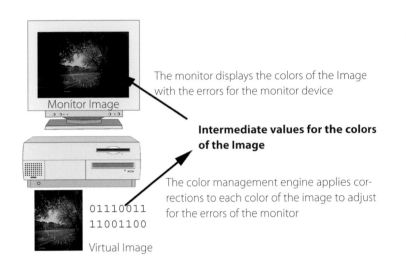

Monitor Image

The monitor displays the colors of the Image with the errors for the monitor device

Intermediate values for the colors of the Image

The color management engine applies corrections to each color of the image to adjust for the errors of the monitor

01110011
11001100

Virtual Image

It is important to note that the color management engine can correct each color independently. That is, the color shift for each color can be calculated and corrected before display or printing. Before color management, we used to shift the entire device to correct for color shifts. Many printer drivers still have color adjustments built in that allow you to adjust the color of the overall print. But devices (like your monitor and printer) don't behave that well. Your monitor might make the bright reds appear too blue and the dark reds appear too green. Therefore, we need to make a calculation for the color shift of each color for that device.

Profiles allow for these specific color adjustments. For the most part, a profile is a list of target colors and the errors in the display of these target colors. A typical monitor profile might have ten different shades of reds for target colors and the resulting color errors of your monitor displays (plus ten shades for each of the various other colors and shades of gray).

▶ A profile is a list of target colors and the errors in the display of these colors by a particular device. Ultimately, in creating a profile, we merely present a device a particular target color and measure the color that is actually rendered.

To create a profile, we use software that sends a particular target color to a device. Then we use some external hardware device to measure the actual color that is rendered by the device. For monitors, we use the monitor profiling software to display large blocks of a solid color on the monitor. Then we use a display sensor to measure the actual colors that are rendered by the monitor. (More on creating monitor profiles in step 4, "Profile Your Monitor")

A monitor sensor measuring the color
from the monitor

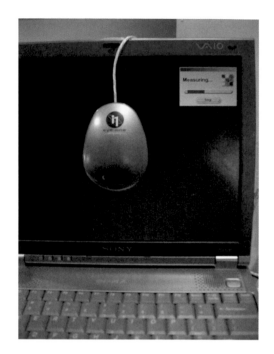

For printers, we use the printer driver to create a printout of a large array of color squares. Then we use the printer profiling software and a device for measuring printer color to measure the actual colors that are rendered by the printer. (Typically, this device is a spectrophotometer designed specifically for measuring colors from printer inks and paper.) Often users can obtain good printer profiles from a variety of sources without having to purchase and use a spectrophotometer. We'll evaluate some of these options in step 9, "Obtaining Profiles".

Using a spectrophotometer to measure
the colors rendered from a printer

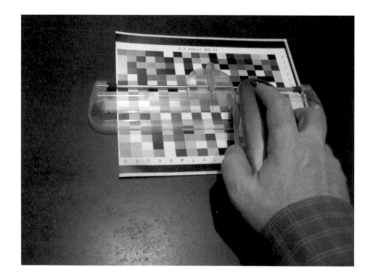

▸ Monitors and printers are profiled and color corrected independently. If we setup both the monitor and the printer to match the virtual image inside the computer, then the printer and monitor match each other as well.

Real world devices have another limitation: there are colors that just cannot be reproduced by a particular device. The real world has a vast array of colors: saturated, brilliant, subtle, muted, dull, and gray. No type of photographic or digital reproduction can reproduce all these colors, yet some devices do better than others. Transparency film can reproduce a very broad array of colors. Projected slides demonstrate the ability of film to reproduce some very vibrant colors. Most devices have one real, severe limitation: printed images render far fewer colors than are seen in the real world.

The limitation in the range of renderable colors for a particular device is described by the gamut of that device. This is a real, physical limitation of a device. Attempting to display colors that are outside of the gamut of the device results in the device simply rendering a similar color that it *can* display.

▸ The gamut of a particular device is the range of colors that can be rendered by that device. Colors that are outside of this gamut simply cannot be rendered accurately by that device. If you try to render these colors, the device simply renders a similar color that it is able to display.

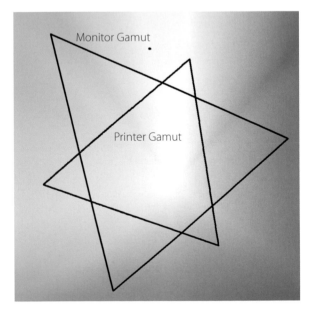

Sample gamuts for an idealized monitor and printer.

Various devices have different limitations of colors that can be displayed. It is often assumed that computer monitors have a larger gamut than computer photo printers; i.e., the monitor can display a wider range of colors

than the printer. This is generally true, but even though printers have a smaller gamut, there are some colors that most computer printers can print that cannot be displayed by most monitors. In general, monitors have limitations in displaying cyan and magenta; printers have limitations in printing greens and blues. In evaluating color management systems, we assume the monitor can display all the printable colors, but this assumption is not 100% accurate.

Due to the differences between monitor and printer gamuts, even an ideally configured color management system cannot assure that the image on the monitor will match the image on the print. Colors that appear on the monitor may simply be unprintable by the printer. To resolve this gamut problem, restrict the colors in your image to colors that are generally within the printer gamut. If your image contains only printable colors, the monitor will display them all accurately, and your printer can print them all as well. We can restrict the colors by selecting an appropriate color space.

▸ Restrict the colors in your image to printable colors: colors that can be both displayed on your monitor and printed by your printer.

To set up a simple and effective color management system, you need to complete three basic tasks: create the monitor profile, the printer profile, and the color space. Typically, you create a monitor profile specific to your own monitor; use profiles that match your particular model of printer, ink, and paper you use for printing; and use the sRGB or Adobe RGB color space to restrict the colors.

▸ The main tasks for color management are:

Configure Photoshop to restrict the colors in your image
Create a monitor profile for your own monitor
Obtain and use profiles that match your model of printer

Step 1 – Select a Color Space

Step 1 is to select a color space for your images, or more precisely, to select a default working color space that defines the colors of your images in Photoshop. As you open images, you'll use this default to convert most images not already using your working color space. Therefore, almost all your image editing will occur using the default working color space you select.

At this point, many readers often jump to selecting "Adobe RGB" as their working color space. Most texts on digital photography and imaging recommend just such an action. And I don't totally disagree, but it's helpful to understand the various aspects of color spaces before making this particular recommendation. Let's first discuss what a color space is and then some important color spaces you might select.

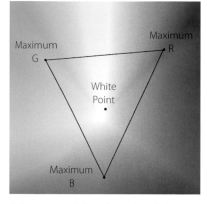

Color spaces define the color of the white point and values for maximum red, green and blue

RGB values require a color space to define specific colors

Only those colors within the reference points of a color space can be defined using the color space. Colors outside the color space cannot be used.

What is a Color Space?

A common problem with the RGB model for representing color is not recognizing that the values of R, G, and B are essentially meaningless without a reference or a scale for these values. An R value of 100 represents a red intensity of 100 points in the range from 0 red to 255 red, but what is "0" and "255"? A color space provides that necessary reference for defining the values for R, G and B. In particular, the color space defines the specific color represented by 0R and 0G and 0B, the white point, and the specific color for each color at 255R, 255G, 255B.

With these reference points, a specific color can be determined for a given value of R, G, and B. But this "specific" color is different in each of the available color spaces.

In the example illustrated, the R, G, and B numerical values are the same, but their reference values point to different colors in each color space.

It is important to note that the reference value for 255R in each color space points to the most vibrant red that can be rendered in that color space. Values of R can't be any larger than 255, so more vibrant reds just aren't available. In this way, color spaces actually limit the range of colors that can be rendered. Some color spaces are "small" representing fewer colors, some "large" representing more colors.

So why not just select a color space that includes all possible colors? Such color spaces do exist.

In the introduction, I discussed the limitations of real world devices such as monitors and printers and the gamut of these devices. These devices simply cannot render all possible colors. It usually isn't practical to select a large color space including colors that aren't possible to render, especially by your printer. One typical criterion for selecting a working color space is that it is similar to the gamut of your final output device. In selecting a working color space, look at the size of the color spaces in relation to the gamut of some common devices.

Also, digital colors are often defined in discrete steps from 0 through 255. This is generally adequate detail for describing most colors, providing millions of possibilities. But very large color spaces define many colors that are simply not usable – the usable colors may only be available in the steps between 0 and 100. This can limit how well colors can be described in a very large color space. Today's imaging systems allow for finer intermediate steps from 0 through 255 when working with images that include 16 bits of data per channel. Using these fine steps, there are thousands of steps between the values of 0 and 100 rather then merely 100 values. In order to make the best use of very large color spaces you should work only with images of 16 bits of data per channel. And remember, images captured on your digital camera as JPEG files are not available with 16 bits of data per channel.

▶ Typically, select a color space that is similar in size to the gamut of your final output device. If you select a very large color space, only edit images with 16 bits of data per channel.

Color Space Options

There are dozens of different color spaces commonly used for image processing, the two most common being sRGB and Adobe RGB. Next, I'll outline the features of these two, and will also describe four other color spaces you might consider. Finally, I recommend that you start with sRGB for basic printing, then switch to Adobe RGB when you're ready for the more advanced printing steps described later in the book.

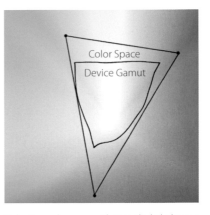

Select a color space that is slightly larger than the gamut of your target device

sRGB

sRGB is the default color space used by Adobe Photoshop. Moreover, it is the default color space used by almost every piece of software and hardware on the market today. sRGB was proposed by Microsoft and Hewlett-Packard as the default color space for the Internet, and Microsoft has worked to ensure that all Windows-compatible products that deal with images understand at least sRGB images. In fact, many software and hardware products merely assume that all images use the sRGB color space. This is the underlying advantage (and curse) of sRGB: almost every piece of software and hardware uses sRGB as its default color space, and many assume your images are sRGB images, even if they're in another color space. This includes most Internet browsers, office applications, publishing applications, digital cameras, and printers. The number of products supporting other color spaces is actually fairly small.

Due to the prevalence of sRGB as the color space used by almost every part of the desktop computer industry, if you use sRGB, you can simply move your images to any of these products and get good results easily. However, if you use another color space (such as Adobe RGB) and use it with a product that assumes sRGB (such as a Web browser), the reference points for each color will be off, and the whole image will appear wrong.

AdobeRGB image on the Web sRGB image on the Web

Typically, Adobe RGB images on the Web appear flatter and more green/cyan than they should. For this reason, even if you wish to work in a color space other than sRGB, convert some of your images to sRGB when using software products that assume sRGB. sRGB has one significant disadvantage. It is too small for many printing applications. sRGB was designed to match the quality of consumer monitors in the mid-90's and is often considered a match for the "worst-of-monitors."

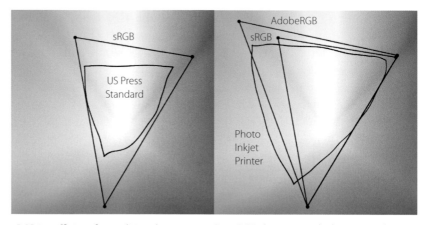

sRGB is sufficient for traditional press machines

But sRGB does not include many colors printable by today's photo inkjet printers

sRGB is a fairly good working space for traditional US press machines (used for typical mass printing like magazines), but it is too small for many of today's photo printers. If you send an image using sRGB to one of these printers, you simply won't have these colors available when you print. Typical color maps like the ones shown above often appear to condemn sRGB quite strongly. It appears many colors are simply excluded by sRGB. In reality, sRGB can represent most important colors fairly well. (Some comparisons of images in sRGB and Adobe RGB follow the description of Adobe RGB.)

▶ The main advantage of sRGB is that it is ubiquitous. If you select sRGB as your default working space, you can probably forget about working spaces thereafter. But remember, because of sRGB's smaller gamut, you may not get the full advantage of your photo inkjet printer. For users new to color management, I recommend selecting sRGB as your color space.

Adobe RGB

Adobe RGB is highly recommended for image editing since it provides good coverage of most printing devices. Most users that are determined to achieve the best quality prints generally work in Adobe RGB. It is important to note that Adobe RGB no longer includes all the colors available to many of today's desktop photo inkjet printers.

Adobe RGB is also (almost) the standard for high-end digital photo printing today. Most high-end imaging and printing applications support Adobe RGB, and many imaging professionals and printing service bureaus expect images to use Adobe RGB. Most imaging professionals rely on products that will support this standard. These products include all of the key Adobe products (including Photoshop, Photoshop Elements, Acrobat, In-Design, Illustrator, and others), many models of Hewlett Packard, Canon, and Epson photo printers, and many models of digital cameras, especially Digital SLR cameras and professional point-and-shoot models. More and more products are adding full color management support that includes support for Adobe RGB. Providing you work with these products, Adobe RGB is great.

The biggest disadvantage of Adobe RGB is that it is supported much less than sRGB. In fact, if you use Adobe RGB as your default working space, you must remember to convert your images to sRGB whenever you want to use these images where sRGB is expected. If you forget to convert, your images will appear flat and washed out. sRGB is necessary for most images on the Internet. In fact, I recommend that you convert any image going onto or over the Internet to sRGB unless you are certain the party on the other end understands Adobe RGB images. This includes images placed on Web pages, emailed to clients or friends, and printed by most online print services.

▸ The main advantage of Adobe RGB is that it is large enough to provide most of the colors available for today's desktop photo printers. Adobe RGB is also very common in professional image editing. The main disadvantage of Adobe RGB is the need to convert these images into sRGB wherever sRGB is assumed, primarily on the Internet.

sRGB vs. Adobe RGB

The debate surrounding sRGB vs. Adobe RGB often reaches near-religious proportions. The reality is that both color spaces are useful. In general, working in sRGB is easier, while working in Adobe RGB produces images with richer colors. But the differences in images rendered using these two working spaces can often be very subtle.

Start working with sRGB if you are new to color management. When you start working with more advanced printing steps in color management, switch to Adobe RGB. These advanced steps include printing with profiles, using the colorimetric rendering intents, soft proofing images, and fine-tuning color for your final print profiles. The advantages of Adobe RGB become more significant with the extra effort needed to perform these advanced steps.

▸ Start with sRGB if you are new to color management.

Most photographers can produce excellent results using sRGB. Switch to Adobe RGB when using the more advanced printing steps in color management.

Some examples:

Image in AdobeRGB Image in sRGB
(Images are identical, because all of these colors lie within sRGB)

Shown above is a basic image containing some rich colors. In this case, all the colors can be represented in sRGB and in Adobe RGB. Such an image appears identical when rendered in either color space. This is fairly common. Of special note is the fact that both sRGB and Adobe RGB include all skin-tone colors, so portraits are generally rendered alike in either. This is not necessarily the case regarding clothing in fashion images.

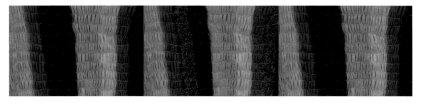

Image in AdobeRGB Colors outside sRGB Image in sRGB (colors
 shown in gray shifted to be inside sRGB)

The example above shows a slightly more complex image that does contain some colors that are not completely rendered in sRGB. The center image shows the pixels that are outside of sRGB as gray pixels. (Photoshop can show the images that are outside of a particular color space or device gamut – more on displaying out of gamut colors in step 8, "Advanced Printing.") Notice that even when these colors are shifted to make all the colors fit within sRGB, the image still appears identical to the Adobe RGB image. I would guess that about three-quarters of all my images appear essentially identical when printed in either sRGB or Adobe RGB, the differences being only a few small spots in my image. However, there is still the remaining quarter of the images to consider.

Image in AdobeRGB Colors outside sRGB Image in sRGB (colors
 shown in gray shifted to be inside sRGB)

The images shown above illustrate a case where the difference between sRGB and Adobe RGB is much more noticeable. The rich blue color of the sky (and some of the warm colors of the grasses) is not available in sRGB. The image looks fine in sRGB, but frankly, the loss of rich blues is noticeable.

Some Other Color Spaces

Although the vast majority of image professionals currently work in either sRGB or Adobe RGB, here are some of the dozens of other color spaces commonly used in image processing, which may be useful to understand.

ColorMatch RGB

ColorMatch RGB was designed to match the gamut of high-end professional imaging monitors made in the 1990's. ColorMatch RGB fits between sRGB and Adobe RGB in size, and covers the gamut of most press equipment well. It became a very popular color space for press shops and printing professionals as color management was introduced. Many press shops now use Adobe RGB but ColorMatch RGB is still common. It is very possible that if you are having something printed professionally, they may request the image be in ColorMatch RGB. I don't recommend using ColorMatch RGB as your default working space, but it's important to know that it's still commonly used.

ProPhoto RGB

ProPhoto RGB is a wide-gamut color space. It includes almost all possible colors and certainly includes all colors printed by all technologies available today. Many image professionals recommend ProPhoto RGB for color management because working in ProPhoto RGB ensures that your images can take full advantage of any type of printer on the market, as well as any printers that will come to the market for many years to come.

The main problem with ProPhoto RGB is the color space is so large that many colors are simply not printable, and many colors are not view-

able on your monitor. You may do some very complex editing on subtle colors that you can never print. Smaller color spaces restrict you to working on colors that are likely to be printable, so the color changes are fairly small when the image is converted to print. Very large color spaces include whole ranges of colors that change quite dramatically when converted to print, and they require advanced printing options in order to achieve good printing results.

Finally, Adobe RGB is actually good enough almost all the time. Even though it does not include all the possible printable colors, the final results from a well-printed image in Adobe RGB and a well-printed image in ProPhoto RGB are usually identical (but not always).

Consider ProPhoto RGB only after you're accustomed to all the advanced printing steps.

eciRGB

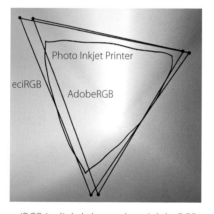

eciRGB is slightly larger than AdobeRGB and provides improved coverage for photo inkjet printers

When Adobe RGB is not quite big enough for your needs, ediRGB is a good alternative. The European Color Initiative (ECI) has created a color space slightly larger than Adobe RGB with the intent of covering the gamut of all printing options.

eciRGB succeeds in essentially including all printable colors within a moderately large color space and is becoming more popular among high-end printers in Europe. However, eciRGB is not included with Photoshop and is not a supported color space in Adobe Camera RAW. To use eciRGB you need to install the color space on your computer, open your images in ProPhoto RGB and convert them to eciRGB. Again, Adobe RGB works well enough most of the time. I include eciRGB to point out that the industry is evolving. In the near future, Adobe could add support for eciRGB to Photoshop, or more likely add support for a new version of Adobe RGB that includes an increase in size. Such a change could alter the contender for "best" color space.

scRGB

Finally, there is scRGB, Microsoft's contender for the next great color space. Their intent is to extend the ease of sRGB to a very large color space that includes all possible colors. scRGB does this by allowing values greater than 255, extending the colors well beyond those in sRGB. scRGB is currently not supported in Adobe Photoshop; it is actually only supported in a few sample applets for software developers. However, it will be the default color space in Windows Vista and will then be an important color space. It should remain extremely simple and may gain rapid acceptance. Products that support sRGB will easily support scRGB because sRGB is merely a subset of scRGB. It will be interesting to see how Microsoft solves the potential problems of a very large color space.

Configuring Your Color Space

Configuring color space is done in the Color Settings dialog; select Edit > Color Settings...

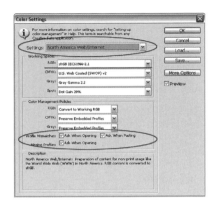

Change the Settings option to the Web/Internet option appropriate for your region of the world (North America, Europe, Japan, etc.). These are the easiest defaults for working with basic color management, plus, you should definitely use these if you're creating images primarily for the Web.

If you wish to change your RGB color working space, change the RGB setting under Working Spaces. Here is where you would select Adobe RGB.

In the section on Color Management Policies, the default behavior for images not in your selected Working Color Space will be Convert to Working RGB. This ensures your images will always be in the color space you selected. Also, if an image is opened that is in a different color space it will open an Embedded Profile Mismatch dialog to warn you that the image's color space is not the same as your working color space. This gives you an option to open the image in a different color space.

Convert to sRGB

Most desktop printers (and almost all online printers) assume that the image you send to the printer is using the sRGB color space. The operating system provides the printer drivers a way to convert to sRGB automatically; this happens via ColorSync on the Mac, and via ICM under Windows. If the printer driver does not support Colorsync or ICM, you need to make sure your images are in sRGB before sending the image to the printer; otherwise the color results can be unpredictable, typically resulting in an image with drab colors.

sRGB original printed as an
sRGB image

AdobeRGB original printed as an
sRGB image

Your printer driver supports ColorSync or ICM if there is an option for these in the printer driver's printing preferences. Check your printer manual and the printer's advanced printing options. If your image is already in the sRGB color space, you don't need to convert it. The Convert to Profile dialog will show the Source Space as sRGB.

To convert an image to sRGB, select Edit > Convert to Profile. You merely need to set the Destination Space to sRGB and click OK to convert. It is likely that your image will appear unchanged.

Step 2 – Get a Good Monitor

Your monitor is your window to the virtual image inside your computer. Ironically, the monitor is often one of the least seriously considered items in a digital darkroom. Yet, it is the basic optical component allowing you to "see" the image inside your computer. If you have a mediocre monitor, you will never be able to see the image inside your computer accurately, and then who knows what your image will look like once it's printed? Mediocre monitors include most laptop monitors, inexpensive LCD monitors, and monitors used frequently for three or more years. I often spend as much money on a monitor as I spend on the computer. For color management, a better monitor is more important than a faster computer processor.

Selecting a Monitor

These days there are many good choices for monitors that accurately reproduce colors. It is your primary tool for evaluating color while editing images on the computer. A good monitor is as necessary as having a good lens for your camera. And even the best components of a digital darkroom cannot compensate for the limitations of a poor monitor.

What about your current monitor? You should be able to profile the monitor with your current computer system to accurately display colors - at least well enough to start the process of color management. There is no need to run out and shop for a new monitor just yet. But if your monitor is older than three or four years, or is especially cheap, it may not be able to render the appropriate range of tones, and you should definitely consider puchasing a new one.

When in doubt, first test your monitor with a monitor sensor. This measures the brightness of the white and black that your monitor generates. If there is a problem, it becomes apparent when you use the sensor to profile your monitor. Old monitors generally display weak whites or show a noticeable color cast. When the whites are weak, the image seems to range between dark gray and light gray. When you use a monitor sensor the software will warn you that the white value is not bright enough. When a monitor shows a color cast, the cast is generally cyan, magenta or yellow due to a weak red, green or blue gun. Again, when you try to calibrate the monitor, the software will warn you if the colors are too far off to be corrected. If your monitor cannot be properly calibrated, start saving for a new one.

CRT vs. LCD: The main question most people have about monitors is whether to go with "LCD" or "CRT." Providing you stay away from the cheapest versions, both are good options for color management. Rather than a long list of trade-offs between these two monitor types, the following table compares the key advantages of each. Often the choice between a CRT and an LCD monitor comes down to the priority between size vs. cost. Personally, I think the greatest advantage of an LCD display is the lack of flicker, making it much easier on the eyes. I do all my word processing and most of my image editing on an LCD monitor. But the computer that drives my printers is connected to a CRT for final proofing before printing.

Advantages of a CRT Monitor	Advantages of a LCD Monitor
Cheaper	Smaller
Reproduces a slightly broader range of colors	Better on the eyes, especially for long term viewing
Better highlight and shadow detail	Cooler (temperature and aesthetically)
Almost always calibrates easily	21st Century Technology – The latest, high-end graphics monitors are all LCDs

Specifically:

▸ If you intend to work in front of a computer screen for many hours at a time, get an LCD.
▸ If cost is a significant factor, don't buy a cheap LCD; rather, get a good quality CRT (and buy the LCD in a couple of years).
▸ If you want the very best color reproduction, both LCD and CRT models can be accurately color corrected.

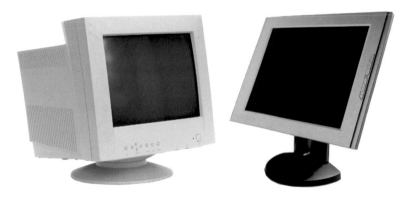

VGA vs. DVI Inputs: Today, CRT monitors usually provide for a standard VGA input to attach to the video card in the computer. Most LCD displays provide both VGA and DVI inputs. The DVI input provides a direct digital connection between the video card and the monitor, and should provide a better image. In reality, the differences between using VGA and DVI inputs are not noticeable today. In the future, as DVI video cards become more sophisticated, the DVI connection will be more useful for providing sophisticated integration between the video card and monitor. DDC/DI is an example of this type of integration. If you get a sophisticated video card (which is not really necessary for working with Photoshop today), then you should make sure that the card is communicating with the monitor via a DVI input.

Resolution: Most monitors have more than sufficient resolution for good image editing. A typical monitor provides about 80 to 100 pixels per inch of detail, which creates a very sharp image on screen. Most monitors

that provide higher resolutions do not actually provide a sharper looking image. Expect a resolution of about 1200x1000 pixels for a 19" monitor and 1600x1200 pixels for a 21" monitor. Importantly, monitors can typically only display images at their native resolution; if you provide a monitor with a signal for a different resolution, the monitor will resample the image to its native resolution for display and the image quality will suffer.

▸ Make sure your video card is set to display at the native resolution for your monitor.

DDC/DI: Many newer monitors now include support for DDC/DI. This is a communication standard that allows monitor calibration and profiling software to make automatic adjustments to monitor controls. These adjustments include brightness, contrast, and color controls. DDC/DI is a nice feature to have on a monitor, eliminating the need to make these adjustments manually. Monitors that lack DDC/DI can still be easily calibrated; it just takes a little time. Apple monitors include similar technology for automatic monitor control adjustments.

Monitor Size: Most computer store sales people will suggest that you buy the largest possible computer monitor, especially for editing photographs. There is some advantage in using a larger monitor, but only within a certain size range. I generally suggest that you purchase a good quality 19" to 24" monitor. If price is a consideration, I strongly suggest that you purchase a better quality 19" monitor over purchasing a cheaper 24" one. Very large monitors are expensive and not especially practical to use. Plus there is a great trick for obtaining a lot of extra computer screen real estate – use dual monitors.

Dual Monitors: Many graphics professionals have two monitors attached to their computers: one for the Photoshop image being edited and one for Photoshop tools and palettes. This is an excellent solution as it is often easier and cheaper to buy two monitors than one super huge monitor. Frequently an older monitor can be kept in service as a secondary monitor alongside a newer and better one.

Both Windows XP and Mac OS X can easily support two monitors. You may need to get a second video card for some computer systems, but typically this costs less than $100 installed. The primary (and better) monitor should be calibrated properly and used for your images. The secondary (and cheaper) monitor does not need to be calibrated (and can't be calibrated on most Windows XP systems).

Secondary monitor
for everything else

Primary monitor for Images

Some Specific Monitor Recommendations

Because of the complexity of choosing a monitor, I am often asked to make specific recommendations, so here is my list. Although this is not a comprehensive list of all the good monitors, I have worked with all of these models directly. There are literally hundreds of good monitors on the market, so don't worry if I haven't recommended your favorite monitor – I just haven't used it. I have attempted to list the monitors in order of increasing cost. The information included in this chapter was accurate as of June 2006. A more up-to-date list of monitors is available on the companion website – www.easycolormanagement.com.

In my digital darkroom, I have a 19" Trinitron CRT, a Sony Artisan CRT (a great monitor that is no longer available), a LaCie 19" Photon LCD and an Apple iMac with built-in display. The next monitor I purchase will probably be the Eizo Flexscan S2410W. I can provide no better recommendation than the fact that I use these.

Sony Trinitron CRT Monitors: These have been the classic workhorse CRT monitors of imaging professionals for many years, but most are no longer being made and they are becoming increasingly harder to find. These monitors have been marketed under a number of brands including Sony, Dell & HP; just make sure that these units are described as Trinitron monitors.

Trinitron monitors are available in 19" and 21" sizes through a number of online discounters for $100–$180. These Trinitron monitors may be bulky but they make excellent color monitors at a reasonable price.

LaCie LCD monitors: LaCie has been making monitors for professional graphics for several years. These monitors are based on the same basic screen technology as some more common consumer LCD monitors, but the LaCie monitors have been calibrated and tested to a higher quality. Prices for The LaCie 19" Photon LCD monitors start at around $450 and range up to $1500 for the LaCie 21" 321 LCD. There are often good deals on repackaged monitors in the Clearance Center of the LaCie store at www.lacie.com. The LaCie monitors are an excellent value for good LCD graphics monitor. I would strongly recommend the LaCie over other LCD monitors in the same price range.

Apple LCD Displays: The current line of Apple cinema displays provide excellent monitors at a decent price. The Apple displays are especially good for their integration with Apple computers. The 20" Cinema displays start around $800.

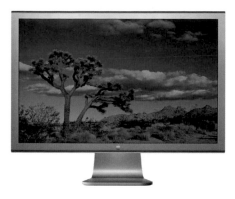

Eizo FlexScan LCD Monitors: Eizo currently makes many of the best graphics monitors on the market today. Many people don't consider Eizo monitors because they think of the expensive Eizo Color Edge models, but the Eizo FlexScan models include much of the technology found in the more expensive units, but at a much more competitive price. This includes 10-bit color correction and automatic brightness stabilization, both of which make the Eizo monitors very reliable for precise color calibration. The Eizo L788 is an excellent 19" monitor that costs about $750 – this is the LCD monitor I most often recommend. I also especially like the S2110W (21") and S2410W (24") models since they provide a large, wide working space – these run around $1200 & $1700 each. These are excellent units for any digital darkroom.

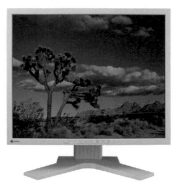

Eizo ColorEdge Monitors: The Eizo ColorEdge models provide the best professional color reproduction available today, but at a steep price. These monitors provide a proprietary calibration program that works specifically with the monitor hardware, extremely good color stability, and a broader color gamut than typical computer monitors. The Eizo ColorEdge C220 monitor is one of the few monitors that can accurately display the full Adobe RGB color space. But these monitors come at a price: the 19" ColorEdge CG19 costs about $1600 and the 22" flagship ColorEdge C220 costs over

$6000. Typically, I usually recommend the less expensive FlexScan monitors for most people who are setting up a digital darkroom. Yet, these professional monitors are especially useful for anyone who requires precisely calibrated results to match work with a remote client. If you are creating professional work that is being checked for final color on a computer monitor, then you should consider a professional monitor.

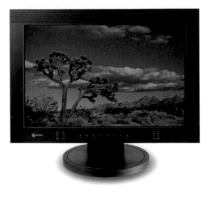

– Probably the best graphics monitor available today

Laptop Displays

Many people want to use their laptops as their primary computers for image editing. Laptop displays are generally designed to be inexpensive and to consume less power, therefore, they have some limitations for color correction. Many just don't have good enough highlight or shadow detail or they have such flat color that they cannot be used for editing color. But several of the newer laptops have increasingly better active matrix displays. (I recently purchased a Sony laptop with an XBRITE display that is fairly good.) Laptops are not ideal for color editing, but they are improving. If you are intent on purchasing a laptop for image editing, buy one with a very good screen.

Another option for most laptop users is to attach a second monitor for image editing. The video output port can be used with almost any type of monitor. Just buy any monitor you would for a desktop, set it up at your workspace, and attach it to your laptop whenever you need to do better color work.

Video Cards

Generally, most current video cards are sufficient for good image editing. Most high-end video cards have features designed for games rather than basic image editing and are unimportant for 2D image editing. Your video card does need to have a Video LUT. In the future, new software will provide some of the same features found in the more sophisticated 3D video cards.

Video LUT: Video cards do need to have a Look-Up Table (LUT) to apply a full monitor profile, but it is extremely rare for modern video cards to lack a LUT. You can test your current video card for a working LUT by downloading the LUT test application from XRite at http://www.xrite. com/product_overview.aspx?Industry=1&Segment=10&ID= 609&Actio n=Support&SupportID=2933; or search online for "LUT Testing Application". This program only works on PCs, though. If your Mac can run OS X, it has an LUT.

The Future: The next generation of operating systems is likely to start supporting the features available in high-end video cards for image processing. The graphics processing units (GPU) available in newer video cards will allow computers to process images ten to one hundred times faster than current imaging applications.

Apple OS X version 10.4 currently includes Core Image which provides GPU support for imaging filters for applications. Though not many applications use Core Image yet, Apple does support Core Image in their Aperture photo workflow application. Apple provides a list of video cards that support Aperture on their website: http://www.apple.com/aperture/. Future applications are certain to add support for Core Image.

Microsoft Vista will use the GPU of high-end video cards for the new Aero Glass user interface, and will provide access for image processing to applications. Currently, only a few video cards are fully supported by Microsoft

Vista; see http://en.wikipedia.org/wiki/Windows_Vista for more details. But the typical Windows Vista computer should provide a supported video card when Windows Vista is on the market.

Windows Vista supports 3D graphics cards for image editing (screen courtesy of Microsoft Corporation, 2006)

I don't recommend that you purchase a video card that supports Apple's Core Image or Windows Vista today, but you may want to buy an inexpensive video card and make sure you can upgrade in the future.

▸ Your monitor is one of the most important elements in a digital darkroom.

You need to calibrate and profile your monitor (step 4). Test your existing monitor if you are unsure of it. Set up dual displays to get a 'big' monitor. Laptop monitors are generally not sufficient for color management, although some laptops now use desktop monitor technology. Your video card is probably sufficient for image editing.

Step 3 – Create a Good Work Environment

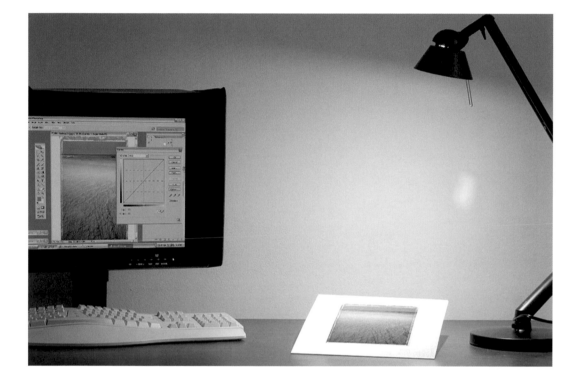

The value of creating a good work environment is left out of many books on color management. Just a few simple tasks are needed to create a good environment for working with color. Studio photographers will recognize some of these tasks. They mostly involve providing good lighting and reducing the presence of distracting colors. These tasks don't involve complex software or tools, yet they are often overlooked. Without a good work environment and good lighting, all the expensive elements of color management are merely wasted.

The Effect of Environment on Color

Color is a strange phenomenon. When I ask students, "What is color?" they often respond, "The wavelength of light." This answer is close, but not really true. The exact same wavelength of light shown in two different environments may appear as two different colors. The intensity, mix of other colors, saturation, and presence of other colors in the surrounding environment can all affect the apparent color regardless of the light wavelength. In fact, color is a much more perceptive phenomenon than a physical one; it happens largely in our brains. This leads to all the complex implications of how the brain actually sees – a subject for a different book. For now, it is important to comprehend that the surrounding environment impacts how a color appears.

A simple example is one of simultaneous contrast. When a color is placed adjacent to a gray field, the gray appears to take on the complementary color. Look carefully at the image of the gray/green color band below. It is merely an image of a band of vibrant green adjacent to a band of flat middle gray. For most, there appears to be a region of subtle red in the gray band where it meets the green band – your brain is adding red to contrast with the vibrant green. Interestingly, this is often red rather than magenta since the brain uses a slightly different color wheel than photography, resulting in slightly different contrasts.

The easiest way to deal with the effects of adjacent colors is simply to remove as much color as possible from the surrounding environment. Make your image-editing environment as colorless as is practical. (Sorry to all you vibrant color lovers; put them into your images, not your editing environment.)

The Environment Matters

The environment in which you edit your images affects how the colors appear. I have seen magnificent labs with the best color management equipment eviscerated by brightly saturated walls making accurate color correction impossible. Creating a good work environment could be the most important, and most overlooked step in color management.

There is no need to go overboard and paint everything 18% gray; just remove intense, distracting colors from your environment.

A Typical (Bad) Digital Darkroom Work Environment

Strong ambient light from tungsten bulbs

Glare on screen from ambient lights

Colorful computer screen

Distracting colors on walls and images in background

No proofing light

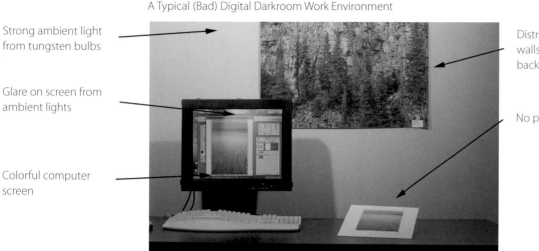

Here are the basic elements for a good working environment for color management.

Room Lighting

Reflected color is a combination of the room lighting color on an object and the actual color of the object. Lighting color is an essential element that affects the final color of an object. When color editing, you also need to keep in mind the color of your room lights.

Don't turn your room lights off completely, though; image editing should take place in a dim room, rather than a dark room. Since your monitor is fairly bright, were you to work in a completely dark room, your eyes would need to adjust too much every time you turn away from the monitor, leading to fatigue and an inability to see color or detail clearly.

Dim the lights so they don't overwhelm the light of your monitor or your proofing light. If you have a window in your digital darkroom, install some good blinds to moderate the effect of outdoor light. Remember, natural light can be very bright and changes color significantly throughout the course of a day. Rather than blacking out my windows, I cover them with good quality white blinds that block 90% of the daylight, but can be opened when I want to proof my images in "daylight."

I still use tungsten lights for my room lights. I use one 100 watt bulb in one fixture that bounces the light off a white ceiling. A 100 watt bulb is bright enough to light a modest-sized room. And bouncing the light off the ceiling creates an even light. Another reason I use the 100 watt bulb is to see how my prints look under good tungsten lights - the lighting used in most homes.

Many people suggest using weaker tungsten bulbs such as 40 watt bulbs. These are okay, but remember, dim tungsten bulbs can be very yellow in color. Others suggest cool white fluorescent bulbs or other near-daylight balanced bulbs. Just pick a room light that doesn't have a particularly strong color cast and that is dim enough to make working in front of your monitor comfortable. Next, we'll talk about preventing room lights from reflecting off the monitor, as well as adding a proofing light.

Use a Monitor Hood

A monitor hood is effective at blocking room light

Rather than work in a room with very dim lights to keep light off your monitor, you could place a monitor hood around your monitor. A monitor is sufficiently bright so that room lights are unlikely to change the appearance of most colors on the screen, but room lights can reflect off the screen and add some color.

A monitor hood is a quick and easy way to help your monitor work much better. Reflected light off your monitor is much like flare in your camera lens. Most expensive monitors designed specifically for color-managed environments come with a nice monitor hood. These are great, but it's quite easy to create a decent monitor hood on your own from black cardboard or foam core and some duct tape. (You should have duct tape in your camera bag.) The monitor hood should have pieces that cover the top and sides and stick out 6"-10" from the monitor. It should be big enough to ensure room light does not reflect off the monitor.

Set Your Computer's Desktop to Boring Gray

Another source of distracting colors in digital imaging are the colors set for the computer desktop. The bright blue color scheme default with Windows XP definitely can affect your ability to view the colors of your images accurately. It is preferable to set your computer desktop colors to something boring and gray.

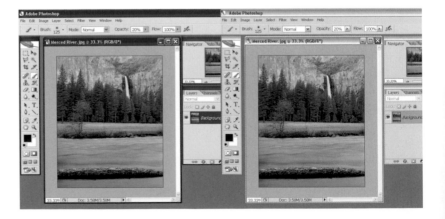

Desktop Image

The boring gray rule also applies to your nice desktop backgrounds. Get rid of them. In Windows XP you can hide your desktop background by merely maximizing Photoshop when editing images. This works fine, but you must remember to do it. In Mac OSX, remove the desktop background and let the desktop be gray.

Windows XP

In Windows XP, the easiest solution is to change the display color scheme to "Silver" which affords good neutral gray values for almost all the Windows controls.

▸ Go to your computer's desktop.
▸ Right-click on the computer desktop to bring up the context menu, and select Properties.
▸ Select the Appearance tab in the Display Properties dialog.
▸ Change the Color Scheme to Silver.
▸ Click on the OK button to accept this change.

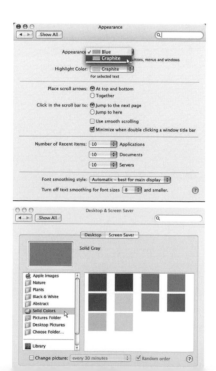

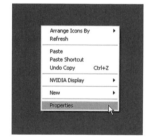

Mac OS X

▸ Select the System Preferences from the System (Apple) menu
▸ Select the option for Appearance.

In the **Appearance** dialog:

Change the Appearance option to Graphite Return to the main System Preferences page and select Desktop & Screen Saver. Set the Desktop to a solid gray color.

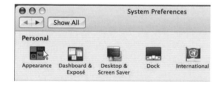

Remove Distracting Colors from Your Environment

You also should remove any strong, distracting colors from your working environment. This task may seem a bit too much. I'm not saying you should get overly hardcore about your room colors. Just remove any strong distracting colors such as bright, saturated images from the walls. It is best if your walls are not colored, since wall colors can dominate your field of vision. Paint your walls a boring color if practical or place a boring background behind your computer if your wall colors are bright.

A Good Digital Darkroom Work Environment

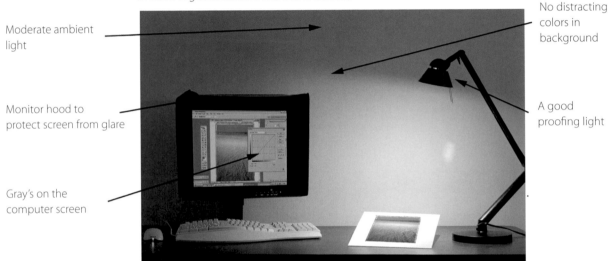

Moderate ambient light

No distracting colors in background

Monitor hood to protect screen from glare

A good proofing light

Gray's on the computer screen

Proofing Light

The last, essential task for creating a good working environment is to get a good quality proofing light. Obtaining a good proofing light is another element typically overlooked in color management, but is just as essential as creating a good work environment. Using a poor proofing light is the most common reason for discrepancies between the image on your monitor and the image in your prints.

The proofing light is the light that is used to evaluate the quality of your prints and compare these to the image on your monitor. Your monitor will be calibrated to match a particular viewing light. A proofing light must be bright, like your monitor, and have a color temperature similar to the calibrated color of your monitor - close is usually good enough.

I recommend you purchase one of three proofing lights: GTI PDV viewing lights, Solux lights, or halogen lights.

GTI PDV viewing lights are industry standard lights for press work. These are calibrated to provide precisely colored D50 light. D50 is the

industry standard for color printing in the US. (Interestingly, it is inherited from color slide film and is not necessarily the best color for proofing fine art images.) GTI PDV lights range in cost from $700 to $1000 and come in various sizes. The unit should include a dimmer that allows you to adjust the brightness to match your monitor. Use a GTI PDV light if you are doing professional work to be printed on a press, including most magazine work, or any other work where your client will be expecting the images to match under a D50 light. Although they are expensive, investing in this type of proofing light will save you a lot of bother when you have your work printed.

GTI PDV Viewing Light

Solux (www.solux.net) sells a number of good lights that provide daylight balanced light, although some are not precisely traditional D50 balanced lights. I recommend the Solux 4700K light since it actually provides excellent D50 lighting. These lights are much more cost-effective for a good daylight color balance than the more professional lights. A complete Solux desk lamp can be purchased for around $200, or you may purchase individual Solux bulbs to place in your own fixtures.

Halogen bulbs provide a light that is bright and slightly warmer than daylight. Halogen lights are commonly used in art galleries and provide a light closer in color to lights used in homes. I recommend halogen lights for proofing prints to be viewed in homes or commercial spaces. In general, halogen lights are very good for proofing most fine art work. but you may wish to adjust the calibration of your monitor to better match your halogen light.

I place my proofing light adjacent to my computer monitor so I can proof my prints and easily compare them to the image on the screen. I can also see how my prints will look under tungsten lights and in natural daylight by moving the print under my room lights or by moving it outdoors.

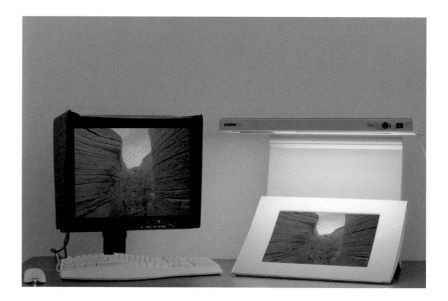

Step 4 – Profile Your Monitor

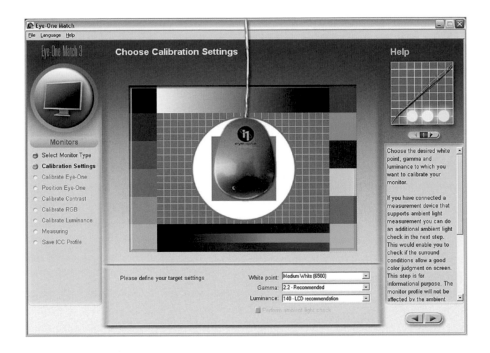

Earlier, I made it clear that the monitor is one of the most important elements in your digital darkroom. It is equally important that the monitor is in good working order. Most users understand the need to get some sort of a puck or monitor profiling tool to profile their monitor, but the reality is slightly more complex.

Your monitor must be both properly calibrated and then profiled for it to render colors well. Calibration requires you to adjust the monitor for its best performance; generally, this involves adjusting the monitor's brightness, contrast, and color settings so the monitor will generate colors as accurately as possible. A profile is then created for the well-calibrated monitor to measure the remaining color inaccuracies to allow the computer to correct for these. Most software products for monitor profiling include steps for properly calibrating your monitor. The products I recommend in this book all include the basic steps for calibration before they perform any profiling. A monitor that is well calibrated and profiled will provide a good representation of the "virtual image" inside your computer.

Tools for Monitor Calibration and Profiling

It is essential to use a suitable tool for monitor calibration and profiling. These are commonly referred to as pucks, spiders, or sensors. There are a number of good tools available, but I recommend the Monaco OPTIX system from X-Rite (www.xritephoto.com) or the Eye-One Display2 from Gretag Macbeth (www.i1color.com). Both tools have an easy-to-use interface for calibration and profiling, and will create excellent color on your monitor. Based merely on quality, I can recommend either of these products. A more advanced option for monitor calibration and profiling is the ColorEyes Display software; I will provide some details on ColorEyes Display later in this chapter.

Monaco OPTIX & Monaco EZcolor

Monaco OPTIX is a precision monitor calibration sensor that is widely available for about $220–$250. Monaco also provides a bundle that includes their OPTIX sensor and their EZcolor software. The EZcolor product provides an entry-level option for creating printer profiles as well as monitor profiles. (More on EZcolor in step 9, "Obtaining Profiles.") Monaco also provides coupons for their OPTIX and EZcolor products with a number of printer and scanner products. The OPTIX product is excellent for those who don't ever want to create printer profiles; the EZcolor/OPTIX bundle is an inexpensive option for experimenting with printer profiles. Monaco also has decent educational pricing for their products; check their website at: ww.xritephoto.com/store/students/ for more information.

Gretag MacBeth Eye-One

The flagship color management product for GretagMacBeth's Eye-One solution is the Eye-One Photo package. This product provides support for creating excellent printer, monitor, and camera profiles. This is a great product, but Eye-One Photo packages start at about $1000. More on the Eye-One in step 9, "Obtaining Profiles." The Eye-One Display 2 is a cost-effective monitor profiling solution and includes a coupon to upgrade to the full Eye-One Photo product.

ColorEyes Display

ColorEyes Display is a replacement software product that works with either the Eye-One Display or Monaco OPTIX sensor (plus a number of other sensors). ColorEyes does essentially the same tasks as the Monaco and Gretag software products, but it produces better results in profiling. These

differences are noticeably better on higher-end monitors that provide subtle highlight and shadow details. I recommend the ColorEyes product for anyone who is using a higher end monitor (Eizo monitors have their own software product available for download.). The ColorEyes Display software is also good at creating very linear, neutral monitor profiles – useful for anyone printing lots of black and white. The ColorEyes Display may be purchased as a bundle with the XRite sensor.

Calibration

Calibration requires that you configure your monitor to its best possible settings to view images. This involves adjusting your monitor for optimal brightness, contrast, color temperature, and gamma (contrast). These adjustments are made using the monitor controls for contrast, brightness, and color balance. Most monitors today provide some level of access to these adjustments via controls on the front of the monitor. You will need to know how to access these controls on the monitor, and they are different for every brand of monitor available. Your monitor manual will show you the location of the controls to adjust brightness, contrast and color.

The monitor calibration software and sensors help you configure your monitor to optimal, target values by measuring the brightness and color of black and white values presented by the software to the screen. When you run the calibration software, the software will first query you for target values for monitor calibration. Typically, the calibration software will help set the monitor brightness, gamma, and color temperature. The default values in both the Monaco and Gretag products are the best place to start.

Default Target Calibration Values

Brightness / Luminance	100lux (CRT) 140lux(LCD)
Gamma	2.2 (for both Mac & PC)
White Point	6500K (or D65)

You may find it necessary to make some adjustments to the target calibration values to better match your monitor and prints. Many users who print onto matte papers (especially those who print black and white images) will use lower values for luminance and gamma. Typical values might be 100lux (for both CRT and LCD monitors) and gamma 1.8. Many users who are proofing with warmer colored lights may also experiment with warmer values for the white point – 5500K is a good value for matching a halogen light.

Profiling

Once the monitor is properly calibrated, it should render images quite well. In fact, a good monitor should display a test image well without any profiling adjustments. The monitor profiling is merely the final touch for making the most accurate monitor display. The monitor calibration software will automatically create a profile as the final step of the calibration process. The software merely displays a full range of color squares on the monitor, which are measured by the sensor. The process is completely automatic; usually requiring about five minutes – enough time to brew a cup of coffee or grab a beer.

Once the calibration software has completed the profiling process, it will display a dialog to name the profile and save it. Provide a name for your monitor. When you save the profile, the calibration software will automatically assign this profile to your monitor within the operating system.

Typically, the calibration software will also provide an option to nag you to re-run the calibration and profiling process again within a certain period of time. This is a good option; I usually set the reminder for about once a month, so that I will re-calibrate at least that often.

Once you have calibrated and profiled your monitor, don't change anything on your monitor or video card. This includes the monitor's brightness, contrast, and color settings, plus the video settings like resolution or bit depth. If you change these, do not assume that the color will be accurate. Return the settings to the original values for accurate color.

Step 5 – Get a Good Printer

A good monitor and properly configured software will make it possible for you to edit your images accurately. The next stage is to make accurate prints. In many ways this is potentially one of the easier options in the digital darkroom. This chapter lists some of my personal recommendations for good printing options for photographers. Almost any printer option can be used to create excellent prints as long as you configure the printer properly and print onto a high quality paper designed for your printer. More information on using printers is found in step 6, "Basic Printing."

The prevailing wisdom among digital photographers claims that you should buy an Epson printer that uses Ultrachrome inks and you need to use printer profiles. This is untrue; there are definitely other good solutions for printing. However, you will find a number of Epson printers listed under my recommendations. I use Epson printers for most of my printing, and these printers dominate the labs I helped setup for photo printing. Read through my list of options before settling on a specific solution.

Keep in mind that my recommendations include only the various solutions with which I am personally familiar, therefore I know these systems work well and there should be one that fits your requirements (there are definitely other good solutions that I haven't listed in my recommendations). I have also tried to organize my recommendations into some general categories since changes in technology may render my specific recommendations out-of-date fairly quickly, yet the general ideas should still be accurate.

In this book, I have included some basic information on printer options. Visit the website which supports this book to find links to more detailed reviews of some of the printers I recommend (www.easycolormanagement.com).

I have received a lot of flak from digital photo experts for recommending some fairly simple printing options, but in my experience, users who choose a simple printing option get back to photographing and start printing wonderful images right away.

Categories of Printer Choices

My recommendations for printing are listed in the following categories:

▸ Inexpensive Photo Printers
▸ Printing Online
▸ HP Photosmart Printers
▸ Epson K3 Printers
▸ Epson Ultrachrome Printers

Below are descriptions, pros and cons, and specific recommendations for each catagory.

Inexpensive Photo Printers

One of the biggest myths of digital printing states that you must buy a fancy printer in order to print beautiful photographs. In today's market, the most important criterion for a good inkjet print is the quality of the paper on which the image is printed. All photo printers today have excellent papers available. I will admit that the best photo printers can produce more vibrant colors and richer blacks, but on the whole you can make beautiful prints from a $99 printer, and the fancier printer will not make you a better photographer.

In general, I recommend that you print photos using a "photo" printer, that is, a printer designed for photographs. These printers use inks that will last many years whereas the inks for many desktop inkjet printers will begin to fade within weeks or months. Also, photo printers are optimized for printing high quality photos.

To get started, you can buy a cheap printer and produce excellent prints without the cost and hassle of some of the more expensive printers.

Pros

Cheap – A good printer can be purchased for less than $100.

Cheaper Ink – In general, the ink prices increase for the higher end printers.

Easy to Use – These printers produce excellent prints very easily, as long as you follow the specific instructions and use the manufacturer's premium photo papers.

Cons

Limited Print Size – Inexpensive printers are limited to printing onto letter (8½" x 11") or legal (8½" x 14") size paper.

Limited Paper Choices – The ease of the inexpensive photo printers is limited to the manufacturer's papers, and many manufacturers support only a few premium photo papers with these printers.

Limited to "Basic Printing" – These easy printers are generally used with the basic printing option described in Step 6. It is possible to perform advanced printing using these printers, but there are little to no printer profiles available for the inexpensive photo printers.

Specific Recommendations

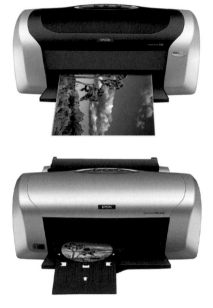

Epson Stylus "C" Series – Although not labeled as "photo" printers by Epson, the Epson C series printers can produce beautiful prints and use DURAbrite inks which share much of the vibrancy and durability of the Epson Ultrachrome inks. Current versions of the Epson C series printers support a wide range of Epson premium photo papers. These printers are commonly available at prices ranging from $60 to $100. I currently use an Epson C86 as my basic desktop printer.

Epson Stylus Photo R220 Printer – The Epson R220 printer is Epson's entry-level photo printer. For about $100, it provides print quality that is every bit as good as most of the Epson premium photo printers. The R220 provides borderless printing, CD label printing, and six-color printing for vibrant images. This is an easy to use printer with excellent results.

Printing Online with a Photo Lab

One of the easiest solutions for printing photographs is to use a good online photo lab service. Simply upload the image files to the photo lab via the Internet and receive great looking images at your doorstep in a couple of days. Inexpensive online services all print digital images onto traditional photographic surfaces, and therefore they produce images that look like "photos". These online services are also increasingly inexpensive, producing good 8" x 10" prints for as little as $2 per print. This is only slightly more expensive than making good inkjet prints, and with this option there is no need to purchase an expensive desktop printer. Finally, online labs can make excellent prints up to 20" x 30" in size just as easily as making an 8" x 10" print.

Nearly all online printing services expect that images use the sRGB color space. Much of the criticism of online printers results from users sending images in a different color space, then receiving fairly ugly prints in return. See the steps for printing online in step 6, "Basic Printing."

It is common to use an inexpensive desktop printer for printing immediate results, and to use an online printing service for larger prints.

Almost all the professional photographers I know use online printing services for some part of their printing work.

Pros

Easy to use – Typically, you merely need to make sure your images are in the proper color space and upload them. Photoshop CS2 provides built-in support for printing using Kodak EZShare.

Easy to make prints at any size – Most online printing services allow you to order prints up to about 20" x 30" – and some support prints as large as 4' x 6'. An online printing service is an excellent option for making large prints.

No up-front costs – You don't need to purchase any hardware or supplies to use online printers. You only need to pay for the prints.

Typically cheaper – Prints purchased online generally cost less than the cost of the ink required to print the same prints on a desktop inkjet printer.

The look-and-feel of traditional photo papers – Most online printing services print onto traditional color photo papers, resulting in final prints that have the same look as traditional photos.

Cons

Fewer paper choices – Many online printing services offer only one or two choices for paper surfaces; often only glossy or matte.

Delayed printing – The prints are often made quite quickly, but must still be delivered to you after printing. The delivery time is typically a few days. This is really the biggest difference between using an online printing service and home printing.

Specific Recommendations

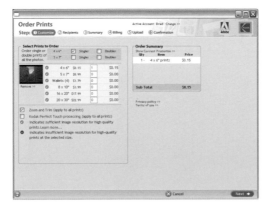

KodakEZShare (Kodakgallery.com) – One of the simplest solutions for printing online; you can print via KodakEZShare directly from Photoshop CS2 and Adobe Bridge. The Kodak prints are of good quality and are inex-

pensive. I use KodakEZShare whenever I need a large number of prints and for my family photos.

Your local online print service –You may have a local photo lab that allows you to send images to them over the Internet. These local labs may not provide all the options of the larger national labs, but they can provide a very fast solution for printing. I commonly send files to my local lab, then drive over to pick up the prints within an hour.

Pictopia – Pictopia provides professional services for online printing. Pictopia allows for advanced printing options using printing profiles available from their website. They also print onto Fuji Crystal Archive paper, which produces excellent, vibrant images. I have used Pictopia for many years for my professional images (www.pictopia.com).

HP Photosmart Printers

HP Photosmart printers represent one of the easiest solutions for printing at home and creating excellent color or black and white images that look like traditional photographic papers. The Photosmart printers easily print images with accurate color via the printer driver. The HP premium matte and premium glossy papers are close mimics to the same traditional photo papers. HP Photosmart printers also have gray inks designed specifically to allow for printing good black and white images. The only major limitation to these HP printers is that they do not support a wide range of papers. The Photosmart printer represents a great option for an easy digital darkroom.

Pros

Easy to Use – The HP Photosmart printer drivers are very easy to use. Merely select the appropriate paper and print quality, then print.

Papers are similar to traditional photo papers – The HP premium matte and premium glossy papers are good mimics to traditional photo papers.

Support for Black and White printing – The HP Photosmart printers can use gray-scale inks to produce excellent black & white prints.

Cons

Limited paper support – The Photosmart printers require the use of HP photo papers in order to get good results and create archival prints.

Specific Recommendations:

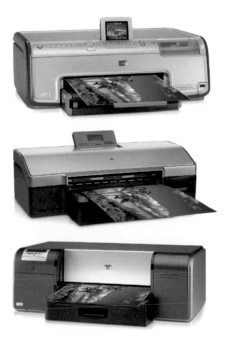

HP Photosmart 8250 Printer – The HP 8250 is an inexpensive option for HP photo printing technology. It creates excellent prints up to letter size using HP premium matte and premium glossy papers. This is a great printer for those who want to easily create good prints at home which have the same look and feel as traditional photographic prints.

HP Photosmart 8750 Printer – The HP 8750 provides for a larger paper size (up to 13" x 19") but has similar technology as the 8250. This printer is recommended for those who want to produce larger prints with the look and feel of traditional photographic prints.

HP B9180 Printer – The HP B9180 printer is a recent addition to the HP photo printer line. It prints on paper up to 13" x 19" and uses pigmented inks. It is targeted at professional photographers and is a direct competitor to the Epson R2400 printer. I expect that the HP product may be every bit as good as the Epson printer, but at this point Epson has a strong lead in third-party support for software and papers. Once paper manufacturers

support the HP B9180 printer, I predict it will be as popular as the Epson printers. I have not used this printer myself.

Epson UltraChrome Printers

The Epson Utrachrome printers were traditionally seen as the gold standard for desktop photo printers, until these printers were replaced by the Epson K3 printers. The Ultrachrome ink works well on a wide range of papers - both photo inkjet papers and fine art papers - and these inks provide excellent longevity. Hundreds of good profiles are available for the Epson Ultrachrome printers. These are the printers used by the vast majority of fine art photographers and their labs. The Epson 4000 is one of the most highly recommended printers in the industry.

These printers require some experience to learn how to create excellent prints. Advanced printing on the Epson 2200 is noticeably better than basic printing on the same printer using the same paper. These are great printers once you learn how to operate them. Today there are lots of used Epson 2200 and 4000 printers available for good prices.

Pros

The standard for inkjet photo printers – There is a lot of support for the Epson Ultrachrome printers; software, printer profiles, tutorials, and online support are widely available.

Printer profiles – The Epson Ultrachrome printers have by far the best support for printer profiles from dozens of paper manufacturers. It is easy to print on a wide variety of paper options with these printers.

Cons

Difficult learning curve – The printer driver for the Epson 2200 (and to a lesser degree the Epson 4000) does not produce excellent prints as easily as the newer Epson printer drivers. Most users recommend advanced printing, using profiles for these printers.

No longer made – Though this printer is no longer manufactured, that is not necessarily a con, but you will find that you can only purchase a used Epson 2200 or 4000 printer.

Specific Recommendations:

Epson 2200 or Epson 4000 – These Epson Ultrachrome printers were the standard for fine art printers for many years. Once you become comfortable with advanced printing, these printers easily produce excellent prints. Almost every inkjet paper manufacturer has profiles available for the Epson 2200 and many have profiles for the Epson 4000. This makes these printers ideal for printing onto a large number of fine art papers. The Epson 2200 is a medium sized printer and produces prints up to 13" x 19". The Epson 4000 is a large printer and produces prints up to 17" wide. The Epson 4000 also uses significantly larger ink cartridges and thus has a lower per print ink cost than the 2200 printer. Both these printers can be found online used and reconditioned.

Epson K3 Printers

Epson released the new K3 inkjet printers in 2005 to replace the Epson Ultrachrome ink printers. These provide an incremental but significant improvement over the Ultrachrome printers. In particular, the printer drivers in the newer printers produce excellent results very easily and the K3 inks print a very rich black on Epson photo papers. These printers therefore combine ease of use with state-of-the-art printing technology. The K3 printers are the new gold standard for fine art inkjet printing.

Pros

Easy to Use – The K3 printers are the first "pro" printers that produce excellent prints when using the Basic Printing steps with the printer driver. There is no need to perform advanced printing steps with these printers.

Black and White prints – The K3 printers can print excellent black and white prints using the Epson printer driver.

Rich Blacks – The K3 inks produce some of the richest blacks available for any photographic process. This results in images with strong contrast and richer looking colors.

Printer Profiles – The Epson K3 printers will eventually have as many, or more, profiles available as were created for the Epson Ultrachrome printers. It is easy to print on many different paper options with these printers.

Cons

Expensive – These printers are not cheap. The Epson R2400 costs about $750, and the Epson 4800 is twice as expensive, making these printers a significant investment.

Specific Recommendations:

Epson R2400 & Epson 4800 – These printers replace the older Epson Ultrachrome printers and are the new standard for fine art printers. These printers produce excellent prints using Basic Printing as well as Advanced Printing. Most inkjet paper manufacturers are creating profiles for the Epson R2400 and 4800 printers. This makes these printers ideal for printing onto a large variety of fine art papers. The Epson R2400 is a medium sized printer and produces prints up to 13" x 19". The Epson 4800 is a large printer and produces prints up to 17" wide. The Epson 4800 also uses significantly larger ink cartridges and thus has a lower per print ink cost than the R2400 printer.

Step 6 – Basic Printing

Printing is a fairly straightforward process. You will have two choices for how complicated you want to make this process. Make your choice depending on the print quality you want and the amount of effort you'll expend to achieve it.

Basic Printing: Current desktop printers and online printing services all produce good results when used as designed. Most users are pretty happy with the basic results of a typical inkjet printer. If you are one of them, print using the steps outlined in the "Basic Printing" section.

Advanced Printing: Advanced photo printers provide options for printing with profiles. Some users will want to take advantage of the full color range of their photo printers and print more precise image colors. The "Advanced Printing" section outlines the steps for printing using profiles.

I usually recommend that you start with the basic printing option to ensure that your color management system is working well before trying the advanced printing options. For many people (including almost all the professionals with whom I have worked), the easy option is great.

Main Elements of Good Printing

The key elements to a good print are often fairly surprising. An excellent print depends more on paper quality and the printer driver settings than the quality of the printer.

Following are the main elements of a good print.

Paper: Paper is one of the most important, yet the most overlooked component of a good-looking print. Even inexpensive printers can produce excellent prints with the correct premium paper. My Epson 980 printer is several years old, yet it still produces great prints when I use Epson Heavyweight Matte photo papers. The printer and the paper are manufactured to work specifically and especially well with each other. Check your printer manual for papers designed specifically for your printer. Select the best paper to get the best print. For basic printing, use the printer manufacturer's premium photo papers. Advanced printing using printer profiles allows for a vast array of papers from various manufacturers. It is advisable to stick to using your printer manufacturer's inks.

Printer Driver Settings: The printer driver includes settings for specifically supported papers, print quality, and color correction. It is important that all these options are set properly. Check your printer manual for specific instructions. The number one cause of poor quality prints is incorrect printer driver settings. (More on this later in the chapter)

Color Space: Good color can only happen if your images are in the correct color space when printed. You should print your images in sRGB unless your printer specifically supports other color spaces like Adobe RGB, or unless you print using profiles as outlined in step 8, "Advanced Printing." See the section on "Convert to sRGB" in "A Color Management Workflow".

Viewing Lights: Printers are generally designed to create images that look accurate when viewed under daylight, but most people view their prints inside under tungsten lights, which are dimmer and more yellow than sunlight. Viewing under tungsten lights results in images that appear to have little shadow detail and a noticeable yellow cast. Even though halogen light is still noticeably more yellow than daylight, it is often considered a better match for viewing prints indoors. It's best to get a good, bright viewing light for viewing your prints. More on viewing lights in step 3.

Printer: Many people believe only expensive, dedicated photo printers print excellent images, but most desktop printers print very good photographs. The biggest advantage of dedicated photo printers are prints that will last many years; manufacturers claim these prints will last more than100 years. This isn't trivial if you want your photos to last. The best photographers look to the newer photo printers designed to print extremely rich colors and gorgeous black and whites. More on printers in step 5.

There is no need to run out and purchase a new, expensive photo printer right away.

First, learn the process for good image editing and printing on your current printer. If you are in the market to buy a new printer, at least buy an inexpensive, modern desktop printer. As you learn, you'll understand your own needs and will be able to make a better choice when you buy a professional level printer.

Using the Printer Driver

The printer driver is the vital software tool for running a printer. The printer is essentially useless without it. In order to get good prints from your printer, you need to use the printer as it was designed. This includes using the appropriate supplies for the printer including both paper and ink, and applying the printer driver settings for the best quality print. If the incorrect paper or printer settings are used, the results can be horrible.

For the most part, the drivers that are shipped with your photo printer are fairly good.

Use the Printer as it was Designed

One of the first suggestions I make to those who are having difficulty with their printers is: read the manual. Your printer manual includes the details for how the printer driver should be used. Traditionally, printer manuals were horribly written, but this problem has improved considerably in the past few years. Also, stories of inkjet ink costing more than fine champagne have lead many users to distrust the manufacturer's claims that you must use their printer inks and papers.

Most printer drivers work very well if they are used as they were designed. Almost all printer drivers require the following three settings:

▸ Set the driver to the specific media or paper type on which you are printing.
▸ Set the driver to its highest quality setting
▸ Make sure the image sent to the printer uses the sRGB color space and set the printer color management to automatic.

A look at the Printer Driver

The Printer driver dialog is accessed once you press the Print button in the Photoshop Print with Preview dialog. Mac OS X and Windows XP have different printer interfaces, so I'll describe these separately below.

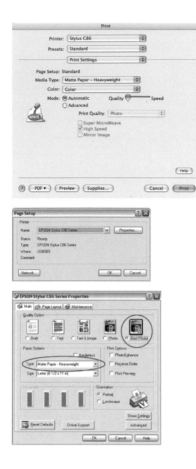

Mac – On Mac OS X, the main printer driver options are accessed by changing the Print Dialog sub-page to Print Settings. This displays the option to setup the specific printer driver settings.

Under the Printer Settings, you merely need to set the Media Type (or Paper Type) to match the specific paper on which you are printing. Be careful, as some papers have similar names, but usually the printer dialog displays the exact name of the paper. Check to make sure that the printer is set to automatic mode and the quality is set to its highest quality setting, as many printers default to a low quality/high speed setting.

Windows XP – On Windows XP, the main printer driver options are accessed by clicking on the Properties button in the Print Dialog.

This displays Properties dialog for the selected printer.

In the Properties dialog, you merely need to set the Media Type (or Paper Type) to match the specific paper on which you are printing. Be careful, as some papers have similar names, but usually the printer dialog displays the exact name of the paper. Check to make sure that the printer is set to automatic mode and the quality is set to its highest quality setting, as many printers default to a low quality/high speed setting.

On Windows XP, the printer driver should default to automatic color management and assume that the image being printed is using the sRGB color space.

Basic Printing

Today, most printers produce excellent color prints as long as you work with the manufacturer's papers and inks, *and* you properly configure the printer driver. Here are the basic steps for printing from Photoshop to a common printer driver.

Now that you've done all the print prep, we're ready to print. Convert the image to sRGB if needed.

Select File > Print with Preview … to access the Print with Preview dialog. The first time you access this dialog, the default settings are set properly for basic printing. But look at the color management settings to understand what they do.

In the Print area, the option for Document should be selected. This also displays the profile or color space for the image to be printed.

In the Options area, the Color Handling option is set to Let Printer Determine Colors. This allows the printer driver to handle the color for this image; Photoshop merely passes the image to the printer driver unchanged. The Rendering Intent option is set to Perceptual. Perceptual is the default rendering intent for most printer drivers.

Rendering Intent defines how the image colors are converted from one profile into another. Use the Perceptual intent for basic printing and the Relative Colorimetric intent for advanced printing.

In the Position area, the Center Image option is checked. In the Scaled Print Size area, the Scale option is set to 100%.

At this point, the preview window reflects how your image would print onto the paper you've selected.

Click on the Page Setup button to open the Page Setup dialog. This dialog is different on the Mac and on Windows.

On the Mac, selections are made for the Printer, Paper Size, and Orientation for your print. First select the printer you want, then select appropriate paper size and orientation.

On Windows, you must first select the Printer button to access the Printer Select dialog. There you may select a printer other than the default printer. In the Page Setup dialog, select appropriate paper size and orientation. Press OK in the Page Setup dialog to return to the Print with Preview dialog.

Now the print preview reflects your image centered on the paper size you selected. If your image appears much larger or smaller than the paper size, you probably didn't follow the print prep steps properly to resize your image. Cancel out of the Print with Preview dialog and resize the image.

Once the preview looks good, and the Color Management settings are correct, click the Print button. Once again the dialog is different between Mac and Windows.

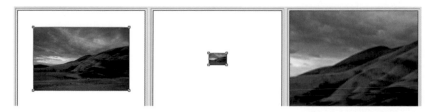

Print preview for a typical image on letter size paper; and images that were not property resized.

Mac Print Dialog

In the Mac Print dialog, select the Print Settings option to access the settings for your printer driver. These settings differ for each type of printer, but almost all printer drivers have options for Paper (or Media) Type, Mode, and Quality. Set Paper Type to match the paper you're using (You'll only have choices of the manufacturer's papers; here Epson's "Matte Paper – Heavyweight".) Set Mode to Automatic, and set Quality to the highest setting available. Check your printer's manual for details on these printer settings.

Next, change Print Settings to the Color Management option. (Some printer drivers refer to this setting as ColorSync, while some have no color management options at all.) For most printers, the default Color Management option is set to Color Controls or Automatic; this works best for most printers. Your printer may also have an option for ColorSync; this may allow your printer to print images in color spaces other than sRGB. Check the printer manual for details on ColorSync.

Finally, click on Print to print the image.

Windows Print Dialog

In the Windows Print dialog, select the appropriate printer from the printer list, and click on Properties to access that printer's print properties dialog.

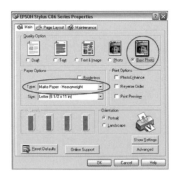

The Properties dialog is different for each type of printer, but almost all printer drivers have options for media type, print mode, and/or print quality. Set the Paper Type option dropdown to match the paper type you want (You'll only have choices of the manufacturer's papers; here Epson's "Matte Paper – Heavyweight".) Set the Quality option to the highest quality setting available. If available, set the print mode to Automatic, Photo, or Quality.

Look for the Color Management options for your printer; these may be available on the Advanced page for the printer driver. The default Color Management option is set to Color Controls or Automatic for many print-

ers. This works best for most printers. Your printer may also have an option for ICM; this may allow your printer to print images in color spaces other than sRGB. Check the printer manual for details on ICM.

Finally, click on Print to print the image.

▸ In the Printer driver dialog, select the paper or media to exactly match the paper you are using, set the driver to print the highest quality, and set the printer's Color Management to Color Controls or Automatic. You might also use ColorSync or ICM for color management.

Online Printing Services

Online printing services allow you to upload your images via the Internet and get high quality prints made onto traditional photographic media. Online printing services have some great advantages: they produce images with the look and feel of traditional photos, they are generally cheaper than similar inkjet prints, they don't require a complex printer dialog, and they typically offer sizes ranging from 4" x 6" (15cm x 10cm) to poster size (20" x 30"). The major disadvantage of online printing services is that the printing is carried out somewhere other than your desktop, therefore it usually takes a couple days to get the final prints. However, there are now a number of local printers that provide online printing which can be picked up in about one hour.

Photoshop CS2 supports online printing directly via Adobe Photoshop Services handled in North America and Europe by Kodak EasyShare Gallery. Similar services are available in other parts of the world.

Kodak EasyShare is an excellent example of a consumer online service. Kodak EasyShare can provide excellent prints providing you conform to their requirements.

To print with Kodak EasyShare, an image must be saved as a JPEG file in the sRGB color space. If your image is already a JPEG file in sRGB, you can skip to step 4, .

To duplicate your image select Image > Duplicate Image ... Give the duplicate image a simple name, such as "my image webprint." If your image has layers, select the option Duplicate Merged Layers Only.

Make sure your image is in the sRGB color space, and that your image is set to 8 Bits per channel to make a JPEG file. Select Image > Mode > 8 Bits /Channel.

Save your image as a JPEG file, select File > Save As ..., set Format to JPEG and click OK. In the JPEG properties dialog, set Quality to 9 – Maximum.

Send a single file to print online by selecting File > Print Online in Photoshop. But more often, you want to save a set of images and print them all together.

Once you have a set of images ready, open Adobe Bridge by selecting File > Browse …

In Adobe Bridge, select the images you want to print online, and then select Tools > Photoshop Services > Photo Prints … This opens the Kodak Easy-Share Gallery and loads your images. (The first time you access Photoshop Services you need to register with them, i.e., supply some basic information and create a login id and password). Within Kodak EasyShare, merely select the prints for each image and check out. If you made sure your images were in the correct format, excellent images will arrive in a few days.

A Color Management Workflow

The basic steps described in this book provide all the essential elements for color managing your images, yet it is important to follow some basic steps with each image. The color management workflow provides the key rules that you should follow for each image.

A Basic Workflow

- Capture using your working color space:
 Set your digital camera to use your working color space Capture digital images in RAW format and use Adobe Camera RAW to set these to your working color space
 Set your film scanner to use your working color space
- Open your images in Photoshop:
 If the images are in your working color space, the images will merely open
 If the images are in another color space, convert these to your working color space
- Identify the color space of images within Photoshop
- Print from within Photoshop:
 Print using the easy printing or advanced printing model

Capture using your Working Color Space

Color management is easiest if you set your images to use the working color space as early on in the process as is practical. For digital camera images this happens either when the images are processed by a RAW file converter (like Adobe Camera Raw) into the working color space; or by setting the color space on your camera if you are using file formats other than RAW, such as JPEG or TIFF. If you are shooting images onto film, these images are set to use your working color space when they are digitized inside the scanning software.

Converting RAW Files

If possible, I recommend that you capture digital camera images as RAW files. These files provide many options for superior editing and fine-tuning the digital images within Photoshop. RAW files also provide an excellent format for archiving the original image before any processing If you process RAW image files into a common working color space like Adobe RGB, you can reprocess these files into a larger color space at a later date, allowing you to wait for a color space that might not exist today.

RAW files also allow images to be processed into 16-bit per channel images in Photoshop. 16-bit per channel images are essential for any level of extensive image editing or if you wish to use any very large color space such as ProPhotoRGB.

Photoshop provides a very good RAW file conversion utility, Adobe Camera Raw, or ACR. There are other RAW conversion utilities available on the market, but the tight integration of ACR into Photoshop makes it highly recommended for most users.

Find the RAW file that you wish to open in Photoshop via Adobe Bridge, through Photoshop's File Open dialog, or in the operating system file structure and select it to open. Photoshop will automatically open this file via ACR.

The bottom of the ACR dialog provides some options for adjusting the image color space – make sure Show Workflow Options is checked.

The main workflow options for color management are the Space and Depth options. Set the Space to match your working color space, and set the Depth to 16 Bits/Channel.

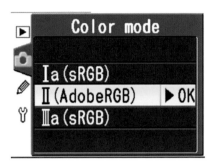

ACR provides support for only four common color spaces. It is likely that you will be using either sRGB or Adobe RGB and will not have any problems with these choices. If you wish to use a color space that is not listed, select ProPhotoRGB within ACR, and convert to your target color space within Photoshop. (More on converting to another color space later).

After you have all the options in ACR set for your image, press Open to open the image in Photoshop.

Capturing Digital Images (not in RAW format)

You may need to capture your digital images in a format other than RAW if your camera does not support RAW files, or you have a need for smaller JPEG files in your workflow. If your camera supports color spaces, then you can set your camera to match the default working color space that you set in Photoshop; typically, sRGB or Adobe RGB.

If you camera does not support color spaces, you should assume that files from your camera are in sRGB, and you should assign these images to sRGB when you open them in Photoshop.

Scanning Film

If you capture your images onto film, you will need to assign a color space to your images when you scan them. Your film scanner is likely to support color spaces including sRGB and Adobe RGB. Set your scanner software to assign (or embed) the same color space as your default working color space in Photoshop.

Set the color space in your scanner software to match your working color space in Photoshop

This is especially important if you Import scanned images directly into Photoshop (by accessing the scanner via the File > Import … menu). It is possible to import images into Photoshop without first checking the color space. Photoshop will assume that the color space is the default working color space, which may be incorrect. Assuming the wrong color space can create an ugly color cast.

Opening Your Images in Photoshop

If you have set your digital camera and/or scanner to use the same color space as your default working color space in Photoshop, these images will merely open when you select them in Adobe Bridge or open them via the File > Open command.

If you open an image that is not assigned the same color space as your default working color space, Photoshop will provide a profile missing dialog or profile mismatch dialog.

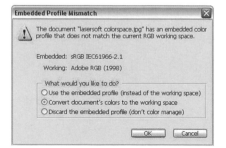

The Embedded Profile Mismatch dialog appears if the image file you are opening is in a different color space than your default working color space. In general, you should convert the image to your working color space – select the Convert option and press OK.

The Missing Profile dialog appears if the image file has no color space assigned to it. In this case, it is reasonable to assume that the file is in the sRGB color space; almost all images that have no color space assigned will look fine when placed in the sRGB color space. Assign the image file to sRGB and then convert it into your working color space.

Identifying the Color Space of Images in Photoshop

Usually, all of the images that are opened in Photoshop will be in the default working color space that you setup in the Color Settings dialog. And you really don't need to think about the color space once the images are inside Photoshop. But you will occasionally have images that are not in your default working color space. Photoshop makes it easy to identify these by placing an asterisk next to the RGB mode identifier in the image title bar.

Image in working color space Image NOT in working color space

If the image is not in the working color space, you can identify the specific color space on the Info palette. Select the Photoshop Info palette, and open the palette menu.

In the Palette Options dialog, select Document Profile under the set of Status Options. This displays the color space of the currently selected image document at the bottom of the Info palette.

Convert to sRGB

sRGB original printed as an sRGB image AdobeRGB original printed as an sRGB image

If your default color space is Adobe RGB, you must convert your images to sRGB for uses where sRGB is assumed; e.g. preparing images for web pages, placing images in standard office applications or sending images to most printers. Otherwise color results can be unpredictable, and typically drab, as illustrated here.

To convert an image to sRGB, select Edit > Convert to Profile. Just set the Destination Space to sRGB ... and set the Intent to Perceptual as shown. Click OK to convert. Your image will probably appear unchanged.

Printing Options from within Photoshop

After working with your images in Photoshop, you will finally want to print them. Follow the steps for easy printing or advanced printing based on the working color space that you are using.

	Basic Printing	Advanced Printing
Working Color Space	sRGB	Adobe RGB
Advantage	Easy, you can forget about color spaces	More printer colors More accurate prints
Web Images	Just save as JPEGs	Convert to sRGB Save as JPEGs
Online Printing	Just print	Probably will need to convert to sRGB
Printer Requirements	Almost any printer will produce good results	Need a printer that supports profiles
Paper Limitations	Manufacturer's papers	Any paper as long as you have a profile
Rendering Intent	Perceptual – easier	Relative Colorimetric – more accurate
Soft Proofing	None	Proof in Photoshop
Printing	Use the printer driver	Print with profiles

There are a few printers that allow you to print from the printer driver using Adobe RGB. These include the Epson R2400, 4800 and HP 8750 printers. You must merely setup the printer driver to assume that the images it will be printing are in Adobe RGB and the rest of the printing model is still based on easy printing.

Step 7 – Test Your Color System

What happens if something isn't working and your prints don't end up look-ing like the image on the monitor? Don't wait for problems such as this. Instead, test the system first.

After implementing all of the basic steps for color management, you can start making prints and comparing the results to what you see on your moni-tor. This isn't a bad model for trying out your color management system, but it is useful to perform a more rigorous test of the system at some point. I recommend testing the system by using a color test image printed from a reliable source.

The Color Test Image

The color test image that I have used for a number of years is the PDI Target file from PhotoDisc Inc., (now part of Getty Images). This image is included in the PDI Target folder on the book's website (a PDF file that includes licensing information on the image is also in this folder). The version that I have included is rendered in sRGB format to make it easier to have a good proof print made. There are a number of other good color test images available. A good color test image includes a wide range of rich colors, a set of neutral colors, some identifiable colors (memory colors), as well as some portraits that include skin tones.

Another good color test image is the Macbeth color checker. The Macbeth color checker is a physical card that is commonly included in test photographs and used to ensure accurate colors. An electronic version of the Macbeth color checker is included in the Macbeth-Target folder on the book's website. This is useful if you actually own a Macbeth color checker card for comparison. Otherwise, don't worry; the PDI target is still very good.

Test 1 – Visual Evaluation

Open the color test image in Photoshop. If your working color space is not sRGB (i.e. Adobe RGB), then Photoshop will present you with an Embedded Profile Mismatch dialog. Select Use the embedded profile (instead of the working space) and press OK. This ensures that the image remains in sRGB for making a physical print of this image. Were you to convert the document's colors to Adobe RGB, the image would appear identical.

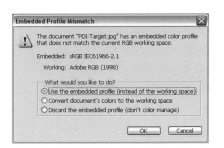

Once you have the image open on your screen, inspect it closely, looking for any color problems. The visual evaluation test is essential, since image editing is a visual process.

Evaluation 1: Overall Color Cast. The overall image should appear neutral on the screen without any overall color cast. Even a slight color cast is likely to be corrected by your brain. If the image has a cool, or bluish cast, you may need to recalibrate your monitor to a warmer white point, (a warmer white point is a lower K temperature value). If the image has a warm, or yellowish cast, you may need to recalibrate your monitor to a cooler white point, (a cooler white point is a higher K temperature value). If any color cast is slight, don't recalibrate until after you have compared the on-screen test image to a printed version of the test image.

Evaluation 2: Neutral Values. Zoom the view of the test image into the central gray patches.

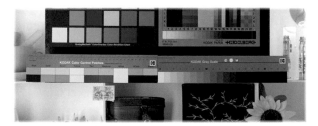

The gray patches should appear generally neutral. It is often difficult for profiling systems to generate completely neutral values on a color system like a monitor, so a slight color in the gray patches is common. A more serious problem with neutral values is the appearance of many different colors along the scale of gray patches (like a green cast in the light gray values and a blue cast in the mid tone values). This can make it difficult to edit grayscale images or images with many gray values. If the gray patches appear to have strong casts or mixed colors, you may need to re-profile the monitor and ensure that the software is set to neutralize the gray values, or you may need to update your monitor profiling software to a version that resolves the gray values. Newer versions of the various monitor profiling software resolve this problem.

Evaluation 3: Skin Tones. The final evaluation test is to look closely at the skin tones in the image. The human brain is able to evaluate colors in skin extremely well, and for the most part skin tones are not particularly difficult colors to render in your monitor. The skin tones should appear natural and healthy. If the skin tones show a strong color cast, it is likely that this cast appears across the entire test image.

Test 2 – Compare a Printed Test Image to the Monitor

Ultimately, the most important comparison is between your monitor and a print displayed under your proofing light. This comparison requires you to have a physical print that is accurately printed from a trusted source (your own printer is not a trusted source). The easiest way to get a good physical print is to send the included PDI-Target.jpg file to a trusted online printing service. You can order a print of your test image directly from Photoshop CS2 using Kodak EasyShare. As long as your image is in the sRGB color space, K odak will produce a very good image. Follow the steps in step 6 page 58 to print the PDI-target.jpg file. The prints will typically arrive in a few days.

Evaluating the printed test image and the monitor

Once you have a printed test image, you can use it to make a more precise analysis of the monitor image. Place the printed test image under your proofing light and open the PDI-Target.jpg file in Photoshop. Compare the image on the monitor to the printed test image. They should look similar. Look for any color differences in the skin tones or the neutral gray values.

It may seem that the proofing light is providing a bit of a color cast to your images. If you really don't like the look of images under the proofing light, you'll need to get another light. All lights provide some amount of color cast on an image; you will need to decide what you prefer. If your proofing light is too warm/yellow, get a cooler/bluer light, and vice-versa. See the section on proofing lights in Step 3 – Working Environment.

Once you have validated the color of your proofing light, you should ensure that the monitor produces an image with similar colors. It is possible that the monitor will display the image either warmer/yellower or cooler/bluer than the printed test image viewed under the proofing light. You can adjust the color of your monitor to more closely match the color of your proofing light by recalibrating it using a different white point value. To make the monitor warmer/yellower – select a lower value for the white point; to make the monitor cooler/bluer select a higher value.

This seems like a tedious step, but it can be very helpful to adjust the monitor white point to closely match the color of your proofing light. And once you have determined the values that look best to you, you will continue to use the same white point whenever you calibrate and profile your monitor.

If you have a Macbeth Color Checker, you can also open the electronic versions of the color checker and compare the physical version to the on-screen version. Again, hold the color checker under your proofing light. The color checker is useful because it contains several, easily identifiable vibrant colors as well as grayscale patches. Also, the physical patches on the Macbeth Color Checker are designed to match the electronic values precisely. The PDI Target contains a broader range of colors and should be used as well.

Test 3 – Compare the Printed Test Image to a Print You Make

Finally, print the test image using your printer. For the first test prints, I suggest that you use a glossy, semi-gloss, or luster paper that is designed for your printer. The Printed Test Image from Kodak EasyShare will be glossy, and it is easier if the finish of the papers is similar.

Look at the print from your printer and the printed test image from Kodak side-by-side under your proofing light. The two prints should appear similar. In fact, they should appear almost identical – the PDI Target image uses the sRGB color space and both prints should be able to print all of the colors in this image well.

There will be some small changes in colors, but typically these will only be noticed if the images are held side-by-side.

If you print onto a matte paper or other softer surface, the glossier printed test image will have darker blacks and appear more saturated. Take this into account when you are making your evaluation.

If there is a strong color cast in the print from your printer, it is likely that you made a mistake in one of the color management settings in the printer driver. When things look completely wrong, I tend to go back to the simplest printing option based on the basic printing steps using the manufacturer's papers and the printer driver. If even the basic prints look inaccurate, it is possible that something has clogged in your printer, or you don't have exactly the appropriate paper.

When printing using profiles, you may wish to print a copy of the test image whenever you try out a new profile. This can be a good way to look for any color issues that might be a result of the profile. Today, profiles from paper and printer manufacturers are becoming increasingly reliable, but there are still many profiles that are simply inaccurate. If you find that you have a poor quality profile, first check to make sure that you have the printer driver setup properly for this profile. It is common that a small change in the driver setup will cause significant color errors in the profile. But you will eventually find bad profiles. Most bad profiles look adequate but have color problems upon close inspection. You will either need to live with the limitations of the profile, or have a profile made to replace it.

This last step comparing the test image from your printer with the printed test image can be performed anytime that you change a profile in your computer or merely want to try out a new paper and the associated profile. It is good to validate the quality of a profile before printing lots of images with it.

Step 8 – Advanced Printing

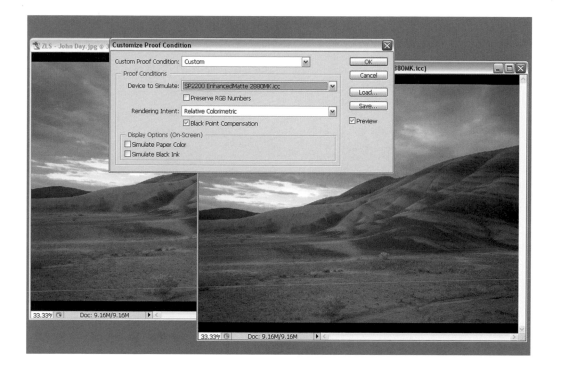

Advanced printing improves the match between the monitor and printer, allowing for more precise color adjustments on the computer before printing. Advanced printing involves using a more complex color space (typically AdobeRGB), printer profiles and more complicated color editing steps. This chapter describes the basic steps for advanced printing. The next chapter – Step 9 Obtaining Profiles – describes how to get the appropriate printer profiles. And the final chapter – Step 10 Adjusting Your Color for Printing – describes various techniques for precise color adjustments that you can do in Photoshop before printing.

After working with profiles for a while, advanced printing becomes fairly easy. Yet, there are many steps for advanced printing and it can be easy to get these steps, mixed up or to miss a step, when you are first learning. The key to good advanced printing is to carefully follow each step.

Outline for Advanced Printing

▸ Edit the image so it looks good on your computer screen
▸ Obtain the correct profile for the printer and paper you will be using.
▸ (More in step 9, "Obtaining Profiles")
▸ Set up the Soft Proof
▸ Look for any color changes due to the Soft Proof and correct these (More in step 10, "Adjusting Colors for Printing")
▸ Print using the Profile you selected in the Soft Proof
▸ Make sure the Printer Driver is configured properly.

Setup the Soft Proof

One advantage of printing with profiles is the ability to Soft Proof the image prior to printing. Soft proofing allows Photoshop to mimic the look of the final print on the monitor.

To set up soft proof, select View > Proof Setup > Custom …

For Device to Simulate select the printer profile for the printer/paper combination you will use to print.

Set Rendering Intent to Relative Colorimetric. (More on rendering intents later in this chapter.)

Turn on Black Point Compensation. This matches the black point in your image to the black ink used by the printer.

Use the Simulate Paper Color option to better mimic the look of the print in the proof. Often, selecting this option makes the image appear washed out. Therefore, you might not want to select this option when using bright white photo papers, but it definitely should be used for papers that are noticeably off-white.

Save a proof setup you use often by clicking the Save button. Give it a useful name incorporating the printer and paper names, like "EPR2400 Prem Luster." This name then appears at the bottom of the View > Proof Setup menu for easy access in the future.

Photoshop now displays a soft proof of how your image will print using this profile. There might be some minor color shifts in the image to correct at this point. Display a new view without the soft proof by selecting Window > Arrange > New Window … for before and after views. The title for each view displays if a profile was applied to it.

Resolving Changes to Colors due to the Soft Proof

See step 10 for steps to resolve color changes.

Printing with Profiles

After you've adjusted the image to fix the out-of-gamut colors in the Soft Proof, printing is similar to the basic printing steps.

Select File > Print with Preview … In the Print with Preview dialog, select Page Setup to access the page setup dialog, and then select the appropriate paper size and orientation. In the Print area, select the Proof option. This also displays the profile you established earlier. In the Options area, set Color Handling to No Color Management. Color management has already been handled by the Proof Setup. Finally, set Proof Setup Preset to Current Custom Setup and turn off Simulate Paper Color and Simulate Black Ink.

Click Print to access the Print dialog.

Make sure the Printer Driver is configured properly

Once again, the dialog is different between Mac and Windows.

Mac Print Dialog

In the Mac Print dialog, select the Print Settings option to set the settings within the printer driver. Here you need to know the appropriate printer settings for the profile you are using. The profile is useless without knowing the appropriate printer settings. Use the instructions that came with the

profile to set up the Print Settings options appropriately. This includes appropriate settings for media, print quality, resolution, and color management. For most printer profiles, set the color management options to no color management, unless otherwise specified.

Finally, click on Print to print the image.

Windows Print Dialog

In the Windows Print dialog, select the appropriate printer from the printer list and click on Properties to access the print properties dialog for the selected printer.

Here you need to know the appropriate printer settings for the profile you are using. The profile is useless without the appropriate printer settings. Use the instructions that came with the profile to set up the Print Settings options appropriately. This includes appropriate settings for media, print quality, resolution, and color management. For most printer profiles, you will typically set the color management options to no color management, but not always.

Finally, click on Print to print the image.

On Rendering Intents

Rendering intents are a key element of color management and deserve a brief section to ensure that you understand what they do. The basic rendering intents are often assigned easy identifiers for the main problems each intent is designed to address; the perceptual rendering intent is often referred to as "easy" or "photographic". These simple identifiers are useful, but you should learn the basics of how these rendering intents work to better utilize each of them.

The Basic Problem – Gamut Mapping

The colors in your images are stored on the computer and within Photoshop using a particular color space, typically sRGB or Adobe RGB. Color spaces are device-neutral; they are not identified with any particular device. But whenever you wish to render an image onto a real device (in particular, when you are rendering the image using a printer onto a specific paper), then the image can only contain colors that can be rendered by that device; it can only contain colors that lie within the device's gamut. The color management module deals with this problem.

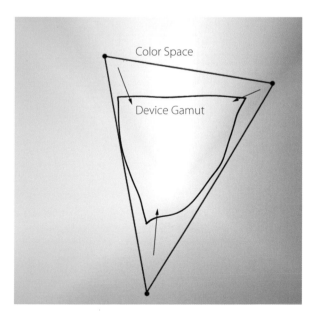

When rendering colors from a color space to real device – the colors that are outside the device gamut must be mapped into colors that are inside the device gamut.

The colors defined in the color space are mapped by the Color Management engine into colors that are available within the device gamut. Gamut mapping defines how colors are translated from one source gamut (or color space) into another destination gamut. There are two basic models for gamut mapping – gamut compression and gamut clipping. All of the rendering intents use variations on these two models.

Gamut Compression

Gamut compression compresses all the colors from the source gamut (or color space) so that they all fit within the destination gamut. This has the advantage of ensuring that colors retain some sense of the relative values from the source colors when mapped into the destination colors; for example, gamut compression ensures that pixels containing super saturated blues will remain more saturated than pixels containing more modestly saturated blues in spite of the gamut mapping. The problem with gamut compression is that all colors within the image will be mapped somewhat; the vibrant colors in the source gamut that are printable within the destination gamut will be mapped into somewhat less vibrant colors through compression. It is important to note that modern gamut compression models are not linear and do not compress colors near to the center of the gamut very much, if at all. Gamut compression is used by most gamut mapping models designed for photographic images.

Gamut compression squeezes the entire source color space so that it fits within the destination device gamut. All colors are mapped in this compression.

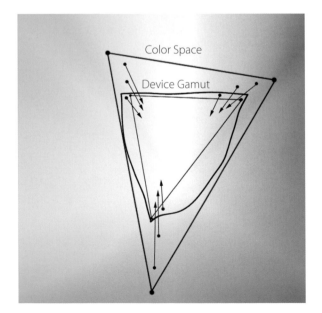

Gamut Clipping

Gamut clipping merely maps colors in the source gamut (or color space) that lie outside the destination gamut to the nearest color within the destination gamut. Colors that originally lie within the destination gamut are unchanged. Gamut clipping performs only the minimal changes to the colors necessary to ensure that all the colors in an image can be rendered by the destination device. Gamut clipping has the advantage that it makes as few changes to the colors of the image as possible. If you spent hours working carefully on the colors of an image and all these colors are printable, gamut clipping will ensure that these colors are printed faithfully. The problem with gamut clipping is that all of the colors from the source gamut that lie outside the destination gamut may stack up around the boundary of the destination gamut onto identical or very similar colors. For example, gamut clipping might translate pixels containing super saturated blues and pixels containing more modestly saturated blues into similar values of blue. Gamut clipping of out-of-gamut colors can result in saturated areas of an image becoming flat or posterized. Gamut clipping is also referred to as colorimetric mapping.

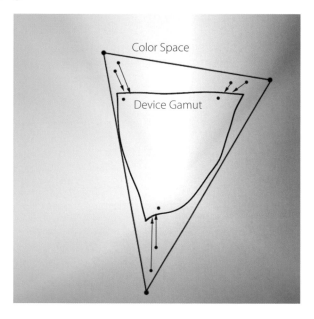

Gamut clipping maps color from the source color space to the nearest colors in the destination device gamut. Colors that were inside the device gamut in the original image are unchanged.,

The Rendering Intents

For almost all photo printing, you will be using either the perceptual rendering intent or the relative colorimetric rendering intent.

Perceptual Rendering Intent (Photographic)

The perceptual rendering intent is often referred to as the photographic rendering intent (or sometimes as "image" or "photometric"). For desktop computer systems, the perceptual rendering intent is the most popular option. The perceptual rendering intent uses gamut compression to map from the source color space to the destination device gamut. Almost all desktop printer drivers use the perceptual rendering intent exclusively, and for most printer drivers, this is your only choice. Typically, you should use the perceptual rendering intent for the basic printing model described in this book. The perceptual rendering intent has some nice advantages. Firstly, most desktop printers also assume that the source color space is sRGB. The limited size of the sRGB color space ensures that almost all colors within sRGB fit just fine within the device gamut for most printers. The gamut compression of the perceptual rendering intent is very limited in this case.

The relationship of sRGB to the device gamut of a typical photo printer. The perceptual rendering intent requires little change to colors in this case.

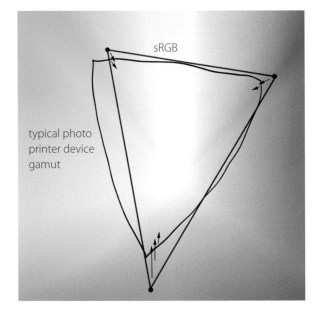

Secondly, the perceptual rendering intent ensures that colors from the source color space retain their basic differences in color, density, and saturation. The human eye and visual cortex are more likely to notice the relative differences in color, density, and saturation than the specific values. The perceptual rendering intent takes advantage of this model. But the limitation of sRGB results in the possible loss of some colors. Also, if you are using a larger color space like Adobe RGB, then the issues of the perceptual rendering intent are somewhat amplified.

Relative Colorimetric Rendering Intent (Graphic)

The relative colorimetric rendering intent is sometimes referred to as the graphic rendering intent (or sometimes as "true color"). The relative colorimetric rendering intent uses gamut clipping to map colors from the source color space to the destination device gamut. Typically, you should use the relative colorimetric rendering intent for the advanced printing model covered in this book. The advantage of the relative colorimetric rendering intent is that all colors in the source color space that can be rendered in the printer device gamut are rendered accurately. But it can cause problems for all colors that are outside of the printer device gamut.

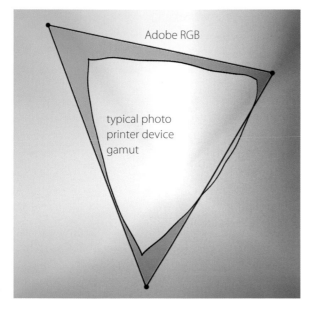

The relative colorimetric rendering intent clips all the colors that are outside of a device gamut to the nearest printable color.
You may need to edit these 'out-of-gamut' colors manually to make a good final print.

Often, you will need to manually edit the colors that are out-of-gamut in order to get the best possible final print. Options for editing these colors are covered in the final step of this book, "Step 10 – Adjusting Colors for Printing".

One important translation that does occur when using the relative colorimetric rendering intent is a mapping of density. Photoshop white in the source color space is mapped to the paper white of the device and Photoshop black in the source color space is mapped to the maximum black of the device. Other tones are scaled in between. This is important to ensure that your image is using the full contrast available.

The Other Rendering Intents

There are two other common rendering intents. The Absolute Colorimetric rendering intent is similar to the relative colorimetric rendering intent, except that it does not scale the black and white points from the source color space to the destination device gamut. This is useful if you want the final print to mimic the white and black values of the source – if you want to make a proof of one device with another. This is common for making a proof print of a print press onto an inkjet printer. For more information look for an article on printing a proof print using your desktop inkjet printer on www,outbackphoto.com in the near future.

The Saturation rendering intent performs gamut clipping, but it also increases the saturation of colors that are within the destination device gamut in an attempt to maximize overall saturation in the image. This is useful for some forms of graphics such as presentations and marketing materials. The saturation rendering intent generally produces poor results with photographic images.

Step 9 – Obtaining Profiles

The main focus of advanced printing is printing with printer profiles designed specifically for your printer and paper, resulting in a more precise match between monitor and printer. This allows careful editing of print colors on the computer before you print and the ability to use most, or all, of the color range available from your printer. In order to print with profiles, you will need to obtain the appropriate profiles for your printer and the paper on which you are printing.

Manufacturer's Profiles

The easiest source of profiles is the appropriate paper manufacturer (including the printer manufacturers that sell papers for their printers). Printer profiles are widely available for a modest number of photo printers on the websites of a number of paper manufacturers. Many manufacturers make excellent profiles for their papers and a number of printers popular with professional print makers. Epson, Ilford, Kodak, Legion Paper, Red River Paper, Pictorico, and others provide printer profiles for their papers via the Internet. Often the paper box provides a website address where you may obtain profiles. You need to obtain profiles for your specific printer model and paper type. Usually, profiles are only available for the printer manufacturer's inks. If the printer can use multiple types of ink (like the Epson 2200 or R2400 printers), be careful about which inks you use. Additionally, find the specific instructions for each profile on how to configure the printer driver. If the driver settings are not configured on your computer according to the instructions for the printer profile, the profile will not print properly. The primary cause of problems with colors when printing using profiles is not having the printer driver configured properly for the specific profile.

An ICC profile file and instruction PDF files

IGSPP9_E2200PSPP_060 PrinterSet_IGSPP9_E220 Read me
4v2 0W

This profile from Ilford is delivered with PDF files that include specific instructions on the printer settings needed to use the profile

Custom Profiles

You can have custom profiles made for you by a professional profile service. These have some good advantages but they cost money. A quick search in Google for "custom printer profiles" found several services which cost around US$40/€30. These companies provide a file of a test target and instructions on how to optimally print this target. After you print the target image, you then snail mail the physical test target to the profile service and they will email the specific profile back to you. Purchase a profile for each paper type you'll be using. The instructions will indicate how to adjust the printer driver settings, and how to keep track of the specific printer driver settings that you use when making the physical test target that you deliver to the profile service. As with profiles that you obtain from the Internet, the

final profile file only works if these specific printer driver settings are used when making prints using the profile.

Making your Own Printer Profiles

Many people who are setting up a digital darkroom will eventually consider making their own profiles. I typically don't recommend making profiles until after you have a smooth running system using profiles from a professional source, either from the paper manufacturer or from a custom-made profile. Making your own good profiles involves some expense and practice.

To make profiles, you will need to first print out a profile target using your printer and the specific paper that you wish to profile. You then need to get the values for the color of each patch in the profile target back into the computer. Finally, you need software to take this patch data and create a printer profile.

The patch data can either be collected using a typical desktop RGB scanner or using a spectrophotometer. There are pros and cons for each of these tools.

Installing Profiles

After you download the profiles, you need to install them. Some of the manufacturer's profiles include an installer that installs the profile for you, but most require that you install them yourself.

On Mac OS X, copy the profiles to the appropriate directory. If you have admin privileges for your computer (most users running their own desktop computers have admin privileges), use the <drive>/Library/ColorSync/Profiles folder. Just move the profile files to this location. If you don't have admin privileges, use the <drive>/Users/<username>/Library/ColorSync/Profiles folder. You will have private access to profiles in this folder. Once installed, you will be able to use these profiles from within Photoshop.

On Windows XP, install the profile by right-clicking on the profile and selecting Install Profile from the context menu. This action copies the profile to the appropriate directory.

Profile Names

Profiles can be named almost anything, but there is a general consensus that a good profile name includes a reference to the printer model, paper and ink (if appropriate). A typical Epson profile is named 'EP2200 EnhancedMatte 2880MK.icc': the printer is EP2200 (Epson 2200), the paper is Enhanced Matte, the ink is Matte Black (MK), and the printer resolution is 2880dpi. With some practice, understanding profile names will become a snap.

Step 10 –
Adjusting Your Color for Printing

The advanced printing described in this book is designed to give you access to the full range of printing colors and to provide precise control over how the colors are printed. When printing with quality profiles, the advanced printing model should yield very little color shift between the image on your computer screen and the final printed image. But no profile can perfectly resolve the printing of "unprintable" colors, such as out-of-gamut colors. The color management engine must change such colors to provide something to print on the paper. This final chapter provides some options for evaluating color changes caused by the profile by using soft proofing, and for you to make corrections if necessary.

Soft Proofing

One advantage of advanced printing with profiles is the ability to soft proof the image before printing. Soft proofing allows Photoshop to mimic the look of the final print on the monitor. The steps for turning on soft proofing are covered in step 8 – "Advanced Printing."

When soft proofing is turned on, Photoshop shows all the color changes that will occur when the selected printer profile is applied to the printed image. For most images, when using soft proofing and the Relative Colorimetric rendering intent, no color shift should appear at all. The Relative Colorimetric rendering intent should not make any changes to image colors that are inside the gamut of the printer profile that you selected in the Proof Setup, and for typical images all of the colors in the image will be available inside this gamut.

Most images show no color changes when soft proofing is used

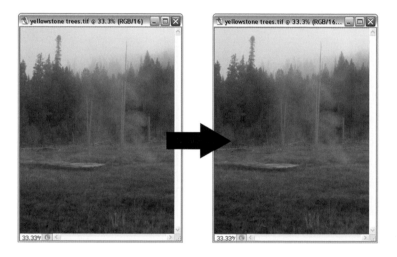

Adobe RGB image Soft proof for Epson R2400 on
 Epson Premium Luster

You may have some highly saturated colors in your image, or you may have selected a printer profile with a limited gamut (i.e., for a soft fine art paper). In this case, your image colors may not be available in the printer gamut, therefore these colors will be shifted to in-gamut colors by the color management engine. Typically, such color changes are very subtle, but not always.

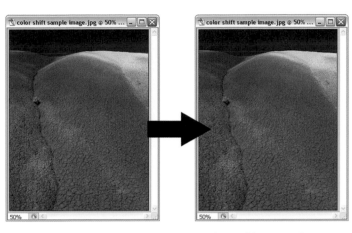

Adobe RGB image Soft proof for Epson R2400 on Epson Premium Luster

Some images show a noticable color changes when soft proofing is used – note the change in the sky color

Soft proofing gives you the opportunity to look for these color shifts before making a print. You can quickly turn soft proofing on or off by pressing Ctrl+Y (Command + Y). Toggle the soft proofing on or off to look for color changes caused by using the selected profile. When you have soft proofing turned on, Photoshop will display the selected profile in the image title bar.

Photoshop provides a very direct method for seeing which colors are out-of-gamut and therefore, must be adjusted when the profile is applied. Turn on the out-of-gamut warning by pressing Shift+Ctrl+Y (Shift+Command+Y). Photoshop will display gray pixels overlaying any pixels that contain colors that are out-of-gamut for the selected profile. This provides a very obvious option for seeing where colors will be changed when using the selected profile to make a print.

Gamut Warning displays the out of
gamut colors clearly

When you first turn on the soft proofing by selecting a Proof Setup in Photoshop, you should toggle the Gamut Warning on and off to see if there are any out-of-gamut colors and toggle the soft proofing on and off to see what changes are being made to the image by applying the selected profile.

If you see no gamut warning or color shifts, that is great, and you should proceed to print this image using the profile normally. Otherwise, you will need to decide if these color changes are significant and then you may choose to edit the colors in your image to enable them to be printable colors.

Fixing Color Shifts

Ideally, when printing using the Relative Colorimetric rendering intent, the only color changes appearing in your image would be a color shift to out of gamut colors, but this is not always the case. Noticeable color shifts may sometimes appear even for colors that are not out of gamut. These color shifts tend to result from the color of the paper and from color casts in the printer profile itself.

Paper Color

Paper color provides the underlying white for your printed image. In reality, no paper is perfectly white; all paper has some density and color. Look carefully at various types of paper under a good bright light (you have a proofing light now) and you should see a variety of colors and reflectance values. Variations in color are most apparent with fine art papers.

I recommend that you turn on the Simulate Paper Color option in the Customize Proof Conditions dialog whenever you are working with a fine art paper and/or a paper with a noticeable color. In general, this is not necessary for most glossy or semi-gloss photo papers.

Even the Relative Colorimetric rendering intent performs some color adjustment to all the colors in the image in response to the paper color. In particular, the black and white points of the image are adjusted to match the black ink and paper white of the final paper. This can reduce the apparent contrast of the image on the screen and this matches the real reduction in contrast of the image on the printed paper. This is particularly noticeable when soft proofing profiles for fine art papers.

Fine art papers may show a reduction
in contrast when soft proofing

Adobe RGB image Soft proof for Epson R2400 on
 Epson Smoth Fine Art

You should carefully evaluate the density changes in your image when you
intend to print onto fine art papers. You may wish to make subtle changes
to the image prior to printing to compensate for the paper color.

Strongly colored papers will also change the overall color of the image.
If Simulate Paper Color is turned off, the resulting soft proof will appear to
have the opposite color from the paper color – the example below shows a
blue color cast for the image when soft proofing for Legion Concord Rag.
When Simulate Paper Color is turned on, the resulting soft proof will show
a color cast similar to the paper color, especially in the print highlights
where the paper color will strongly show.

Paper color can affect the print color,
especially for strongly colored papers

Adobe RGB image Soft proof for Epson R2400 on Soft proof for Epson R2400 on
 Legion Concord Rag without Legion Concord Rag with
 paper color paper color

Here you should definitely soft proof with Simulate Paper Color turned on to see the real colors of the final print. You may wish to make some final color adjustments before printing.

Color Cast in the Profile

Sometimes there will be an apparent color cast added when soft proofing. This is often caused by a problem in the profile. Ideally, a good profile should cause no color shift to the colors that are in-gamut when using the Relative Colorimetric rendering intent. If possible, you should merely replace an incorrect profile with a better profile, but this is often not practical. In reality, profiles from different sources (i.e., from different paper manufacturers) will have slightly different color casts, and you may need to correct these to create prints that have the exact color you intend.

To correct a color cast, you should create a duplicate image on which to apply the soft proof plus any necessary correction. Turn off the Soft Proof for the original image. Select Image > Duplicate Image … and create a new image for the soft proof. Turn on the Soft Proof for the new image and compare it to the original image.

Original image

Image with soft proof enabled
(the profile is shown in the title bar)

The original image in Adobe RGB and a duplicate using the soft proof

You can now make adjustments to the soft proof image to more closely match the original image. You should make these adjustments using adjustment layers so they can be copied to other images that you might print using the same profile.

Resolving Out-of-Gamut Colors

Most of the color changes that appear when using soft proofing happen to colors that are unprintable. Remember, Photoshop and your monitor can display colors that are simply impossible to print – these colors are referred to as 'out-of-gamut'. The colors that are 'out-of- gamut' depend on the specific printer, ink, and paper that you are using for printing and are therefore calculated whenever you select a specific printer profile – as you did when you selected a profile in the Proof Setup above. These 'out-of-gamut' colors must be changed to printable in order for them to be printed. The relative colorimetric rendering intent fixes these colors by gamut clipping but this is not always the desired result. You can also manually edit these colors to bring them into gamut before printing.

Inspection

When you first turn on soft proofing, toggle the gamut warning on and off to see where there are out-of-gamut colors in your image (press Shift+Ctrl+Y/ Shift+Command+Y). Zoom into areas that contain these colors to take a close look at how the profile will change these out-of-gamut colors. Typically, I zoom into actual pixels to look closely at these changes (select View > Actual Pixels and use the navigator window to move to where the out-of-gamut colors are in our image). Then turn off the gamut warning and toggle the Proof Colors on and off (press Ctrl+Y / Command+Y). This will display the changes to these colors when the selected profile is applied.

You should first make sure that the out-of-gamut colors cause a problem. Often the gamut clipping by the Relative Colorimetric rendering intent provides good results, in which case you can ignore the problem and just proceed to printing. Often, there will be no visible problem caused by out-of-gamut colors.

Gamut clipping can still cause two noticeable problems. Firstly, the color change might be a change that is undesirable for the final image.In the example shown below, the bright blue sky is shifted to a darker printable color, but I might prefer the brighter sky. Secondly, the gamut clipping might produce a solid patch of a single color that creates an artificial look to the image.

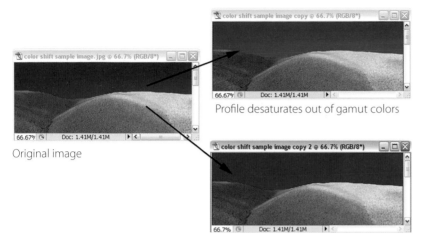

Original image

Profile desaturates out of gamut colors

Profile posturizes out of gamut colors

If the out-of-gamut colors look wrong, you should adjust these colors using the following tools: change the rendering intent, reduce saturation, and/or change the out-of-gamut colors individually.

Change Rendering Intent

The simplest option for fixing problems with out-of-gamut colors is to change the rendering intent. Select View > Proof Colors > Customize to access the Customize Proof Conditions dialog again. Change the Rendering Intent to Perceptual.

The Perceptual rendering intent resolves out-of-gamut colors by gamut compression, so it affects all the colors in the image, but it performs this gamut compression effectively. Gamut compression is especially good for eliminating large patches of colors that might appear in soft proofing.

If changing the rendering intent improves the soft proof, go ahead and print the image normally using the profile, but make sure to set the Rendering Intent to Perceptual in the Print with Preview dialog.

Try changing the rendering intent first to fix any problems with out-of-gamut colors; it often works well.

Reduce Saturation

If the soft proof of out-of-gamut colors just produces the wrong color effects, you should correct the colors manually to make them in-gamut colors. The easiest tool to fix these is the Sponge tool, which can desaturate the out-of-gamut colors.

Display the out-of-gamut colors by selecting View > Gamut Warning … As illustrated, pixels that contain colors out-of-gamut, display with a gray overlay.

You should also have a view that shows the image colors as you are desaturating them in order to see the final results. Create another view of the image by selecting Window > Arrange > New Window for your image. You may also need to make sure that the proof colors are displayed in this new view by selecting View > Proof Colors.

In the case where the out-of-gamut colors are clearly defined (in this example, the out-of-gamut colors are limited to the blue sky), you may want to select these colors to protect the other colors in the image.

Now select the Sponge Tool. It can be found on the tool bar under the Dodge tool. The default options for the sponge tool usually work fairly well. The Mode should be set to Desaturate; the Flow adjusted to how strongly the brush will desaturate colors; and the Brush size can be adjusted as with any brush using the square bracket keys.

Move the Sponge brush over your image and size it to paint on the out-of-gamut colors. Then start painting. The colors in the image should slowly desaturate.

As you paint, the out-of-gamut warning will start to disappear as colors are desaturated enough to be in-gamut. Don't paint any further. Typically, I paint until the out-of-gamut warning becomes a speckle of gray pixels.

When you have completed sponging down the out-of-gamut colors, take a close look at the soft proof of the image to ensure that the colors are acceptable.

Color Mapping with Change Color

Finally, you can change all out-of-gamut colors that are noticeably incorrect into in-gamut colors of your choice by using the Change Color tool.

Display the out-of-gamut colors by selecting View > Gamut Warning. As illustrated, pixels that contain colors out-of-gamut display with a gray overlay. If no pixels display gray, or if there are only a few "speckles" of gray on the image, don't worry about the gamut and proceed to print the image. If there are large areas of solid gray in the image, shift these colors to printable colors. Printing an image with large areas of out-of-gamut colors results in an image with large patches of solid color.

Use the Replace Color tool to shift out-of-gamut colors. Select Image > Adjustments > Replace Color.

Move the cursor over the image and click on one of the large patches of gray. This selects the out-of-gamut color to be shown as the Color at the top of the Replace Color dialog.

Next, select a color in-gamut to replace this color. Click on the color square for the Result color. This brings up the Color Picker. Move the cursor over the image and click on a color that is similar to the out-of-gamut color, but that is in-gamut. When you click on a replacement color, the gray of the gamut warning dramatically reduces. Try a few colors to see which color provides the best result. Click OK to close the dialog.

It's important to preview the change. Select Undo/Redo (Command/Ctrl +Z) a couple of times to turn the Replace Color change on and off.

Finally, reduce the effect of the Replace Color tool to as low a value as possible. Select Edit > Fade Replace Color. Reduce the opacity of the Fade until the gamut warning begins to appear again. It's best to print with some gamut warning, so you are printing right at the edge of the gamut and taking advantage of the full range of printable colors.

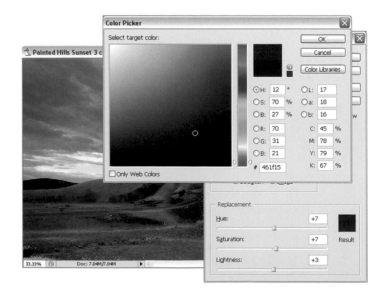

It is possible that you will need to perform the Replace Color adjustment more than once for different colors. Repeat these steps until the gray of the gamut warning is reduced to a mere speckle.

Index

Klaus Goelker
GIMP 2 for Photographers
Image Editing with Open Source Software

Klaus Goelker
GIMP 2 for Photographers
Image Editing with Open Source Software

Image editing has become a key element in the photographic workflow. Image editing tools, most notably Photoshop, are usually sophisticated and deep applications - and are fairly expensive. The only open source tool in this market is the GIMP, which has developed into a powerful, multiplatform system running on Linux, as well as OS X and Windows. This book has evolved from the classroom materials which the author developed and taught in courses and workshops on image editing with the GIMP. It covers the basics of image editing and guides the reader through the functions and tools of the GIMP from simple adjustments to more advanced techniques of working with layers and masks. The more important editing functions are presented in individual workshops. Moreover, the book covers the stitching of panoramic images and preparation of high-quality black and white images.

October 2006, 200 pages, Includes CD
ISBN 1-933952-03-2, $29.95

"The heart and mind
are the true lens
of the camera."

YOUSUF KARSH

Rocky Nook, Inc.
26 West Mission St Ste 3
Santa Barbara, CA 93101-2432

Phone 1-805-687-8727
Toll-free 1-866-687-1118
Fax 1-805-687-2204

E-mail contact@rockynook.com
www.rockynook.com